IMAGES
of America

SAN FRANCISCO'S
OCEAN BEACH

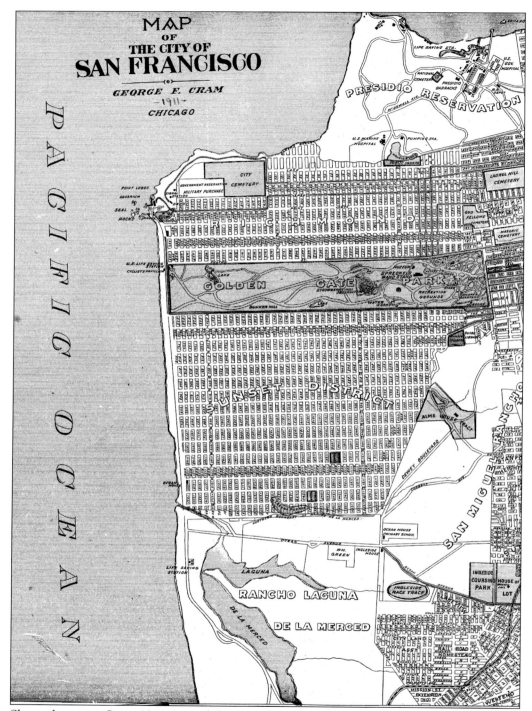

Shown here is a Cram 1911 map of the area of San Francisco called "Ocean Beach," which extends from Point Lobos on the north approximately five miles to Lake Merced to the south.

The front cover shows the statue of Prometheus looking south from the Parapet on Sutro Heights.

IMAGES
of America

SAN FRANCISCO'S
OCEAN BEACH

Kathleen Manning and Jim Dickson

ARCADIA
PUBLISHING

Published by Arcadia Publishing
Charleston SC, Chicago IL, Portsmouth NH, San Francisco CA

Printed in the United States of America

Library of Congress Catalog Card Number: 2003110507

For all general information contact Arcadia Publishing at:
Telephone 843-853-2070
Fax 843-853-0044
E-mail sales@arcadiapublishing.com
For customer service and orders:
Toll-Free 1-888-313-2665

Visit us on the Internet at www.arcadiapublishing.com

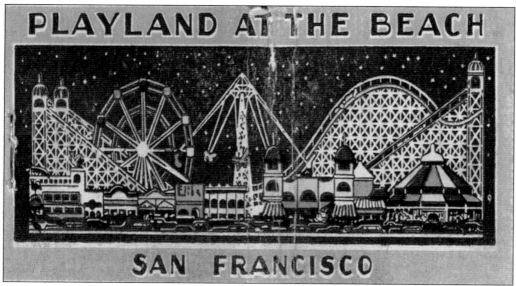

In this artifact, a c. 1950 match book cover from Playland at the Beach, attractions such as The Big Dipper, Loop-o-plane, and the Ferris Wheel are clearly shown.

CONTENTS

ACKNOWLEDGMENTS

It would have been impossible to publish this book without all of the wonderful research done in the past. So many natives and newcomers to San Francisco enjoy keeping the past alive, and these dedicated people love to share their knowledge and collections. Most of the photos and ephemera in this volume are from the authors' collections, but we must give special credit to the San Francisco Public Library Archives. We also want to thank the Smit family, Rick and Tiffany Campilongo, Joe Mirante, David T. Warren, Andrea Souza, and Bill Hall of Prints Old & Rare.

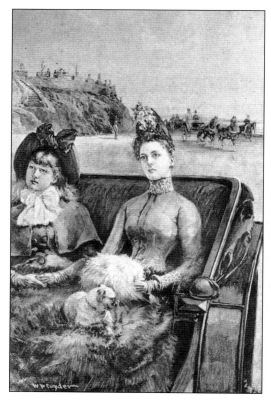

Stylish women tool along on Ocean Beach in front of Sutro Heights in 1889.

6

INTRODUCTION

At the very edge of San Francisco, where the land ends and the Pacific crashes against the cliffs and shore, is an enchanting and spectacular place where everyone from the early millionaires, celebrities, residents and visitors alike, relaxed, enjoyed, and played. This place is known as Ocean Beach.

In the 19th century, the rich would arrive with their splendid horse teams, and if there was room, their coachman would park while the gentry would repose at the early Cliff House hotel for food, drink, and entertainment while viewing the ocean cliffs, as well as the Seal Rocks, from their lofty perch.

Enter Adolph Sutro, a wealthy immigrant who made his money long after the railroad and gold millionaires had. Sutro arrived in the 1880s flush with cash from the famous silver mines of Nevada known as the Comstock Lode. Sutro was so rich, he was able to buy $1/12$ of the entire city of San Francisco. Instead, he chose the cliffs at Ocean Beach adjacent to the Cliff House as the site to build a magnificent mansion with fabulous gardens, surrounded by Greek statuary. He encouraged residents and visitors alike to view the splendor of his palatial surroundings, and also bought and remodeled the adjacent Cliff House.

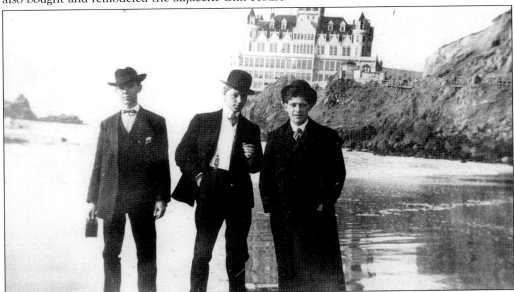

Three "gay blades" are seen here enjoying a day at Ocean Beach.

In the 1890s Sutro began work on Sutro Baths, his most ambitious project, building the largest indoor bath complex in the world. This mining man used his mining skills to bore into the solid rock of the cliff below him to create seven huge pools, each at differing temperatures to accommodate 10,000 people overall. He then enclosed the pools with a huge glass building, including balconies and seats for up to 25,000 spectators. These people came not only to view the swimmers but to be dazzled by the bands, the fireworks, the circus acts, and the inspirational lectures. It became the West Coast Chatauqua.

After the baths were completed, Ocean Beach became so popular that autos often couldn't find parking room and had to be turned away. Additional establishments such as The Chutes and Seal Rock Inn provided a setting for festivities, sporting events, entertainment, and amusement.

In the 1920s, a large amusement park rose up a few hundred yards beyond the Cliff House. This complex, known as Playland at the Beach, attracted even more people who flocked to the Ocean Beach area to enjoy the rides, the sideshows, and the midway games.

Ocean Beach had truly become San Francisco's playground. Located where it was at the extreme edge of civilization not far from the entrance to Golden Gate Park, it still retains its place today as one of the premiere destinations for visitors of San Francisco.

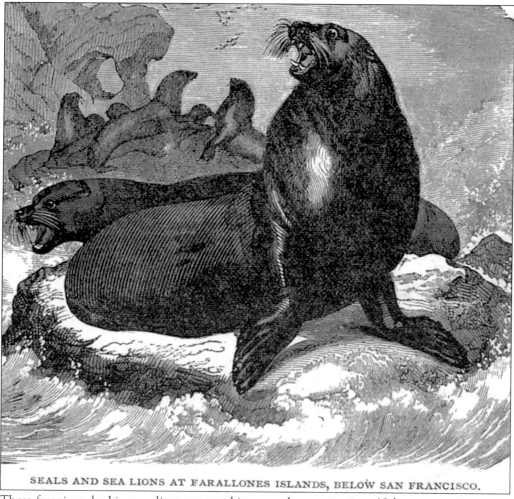

SEALS AND SEA LIONS AT FARALLONES ISLANDS, BELOW SAN FRANCISCO.

These ferocious, barking sea lions appeared in a wood engraving in a 19th century print.

One

HISTORY OF

OCEAN BEACH

Before the Europeans arrived, Ocean Beach was part of a vast sand dune. The area had no permanent settlements. San Francisco Bay itself was not discovered until 1760 by a land expedition led by Gaspar de Portola. The entrance to the bay had been overlooked by Spanish explorers because of the mountainous coast, rocky beaches and, of course, the fog. In 1774 Capt. Fernando de Rivera Moncado and Fr. Francisco Palou, along with four soldiers, climbed a summit at Point Lobos (adjacent to Ocean Beach) and erected a cross. On this 381-foot summit, they erected the standard of the Holy Cross, supported by two rocks. The views from this part of the Golden Gate are magnificent. About 11 miles to the south San Pedro Mountain can be seen, with its treacherous Devils Slide where today's city of Pacifica lies. To the north sit the Marin Headlands, and to the west the Farallone Islands can be sighted in the distance. In 1775, Juan Ayala sailed past Point Lobos and called it "Punta de Las Lobos Marinas" (Point of the Sea Wolves), marking the time at which Europeans finally entered San Francisco Bay.

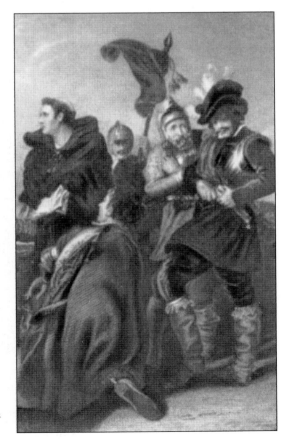

(*right*) This is an engraved view of explorers and missionaries arriving in the Bay area.

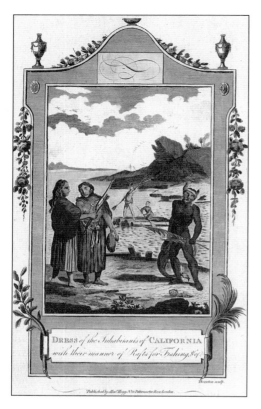

The Indian population, called Costanos (Coast People) by the Spaniards, by and large did not frequent Ocean Beach. As they were hunters and gatherers, an easier life existed inland, away from the cool foggy coast.

The whole western edge of San Francisco was a series of sand dunes with no trees in evidence. The flora was primarily coastal brush and dune scrub. This 1870 view from the Cliff House is an old steriopticon card, and it shows these vast sand dunes then known forbiddingly as the "outside lands."

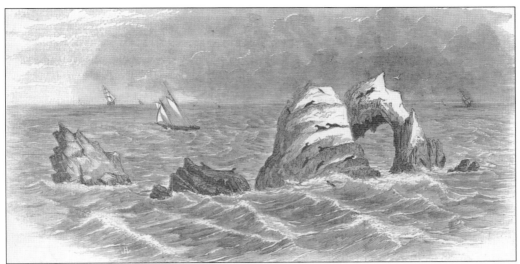

This 1857 wood engraving from *Frank Leslie's* magazine stated the following: "A little southward are situated the Seal Rocks represented in our splendid engraving; they are peculiar from the fact that the largest one presents an arch, which gives it a very picturesque appearance. These places in old times were remarkable as the resorts of sea lions, some of which obtained the enormous size of two thousand pounds; one was once killed at Bodega, a little north of the harbor that weighed three thousand pounds. When resting upon the rocks and dried in the sun these huge monsters are of a dirty tawny color and present a disgusting and formidable appearance, particularly when they throw their huge and always exposed tusks into the air, swinging their heads to and fro and bellow with a roar that can be heard for miles."

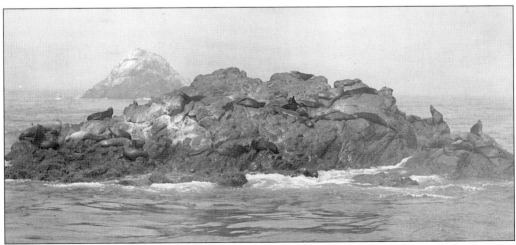

This is a wonderful example of a cabinet photo view of Seal Rocks during the 1860s. In 1857 *Harper's Weekly* had this to say about Ocean Beach: "The voyager is impressed with the gloomy appearance of the scene before him; a multitude of low, black sand hills are partially visible over which continually sweep, like disturbed spirits, flying clouds of dense mist. Passing gradually into the strait, the scene constantly increases in interest. The surrounding hills assume a more positive form; the islands become bold and rocky, and in some parts precipitous, swelling at times into towering mountains. The strong winds and heavy fog which constantly assail the land, prevents trees and luxuriant vegetation."

Harper's Weekly in 1857 described the approach to the Golden Gate and cliffs of Ocean Beach: "To our right, as we draw farther in, appears the famous arched rock, which, small as it looks in the distance, is of formidable dimensions, and has been visited by innumerable sailing-parties from San Francisco as a remarkable natural curiosity. On the summit above, stands the well-known telegraph station of the marine reporters, Sweeny and Baugh, pioneers in the electric telegraphs on the Pacific Coast. In 1852 they constructed a line at their own expense, several miles in length from their station to the old Merchants' Exchange in San Francisco. Below, on a shelf in the precipitous bank, is their fog-bell, which they keep tolling, gratis, for the good of the sea-faring world in general, whenever the fog will not permit the lights to be seen."

This is a wood engraving of the Telegraph Station of Sweeny & Baugh from *Frank Leslie's* in 1856. At the sighting of an incoming ship, the lookout would indicate (by semaphore) the kind of ship, which would be relayed manually to other signal stations. By 1853, the electric telegraph replaced the old system, and ship sightings were flashed to the Merchants Exchange for quick response by the businessmen who would meet the ships.

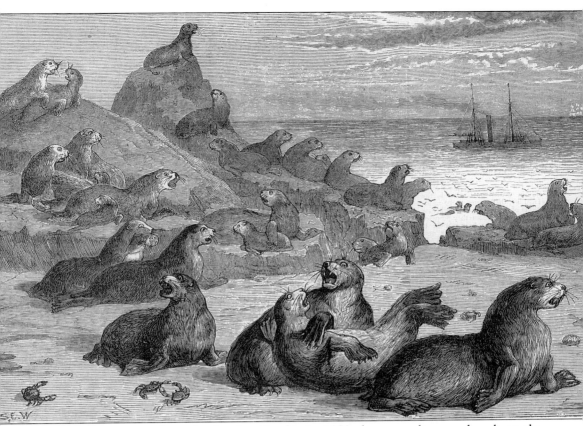

This wood engraving from the *London Graphic* in 1878 shows sea lions and seals at the rocky cliffs. The Seal Rocks are massive sandstone cliffs once part of the mainland. Flocks of cormorants and oystercatchers were part of the scene, and the bays and coves of the coast were populated then as now by hundreds of thousands of sea lions, otters, and California seals. Stellar sea lions are the largest creatures, with the bulls averaging 1,400 pounds, and measuring up to 11 feet in length. California sea lions, sometimes called seals, are smaller and darker; all have a thick layer of fat under their skins to insulate their bodies from the cold ocean water. They eat fish, squid, and octopus and are able to climb, albeit slowly, over the rocks.

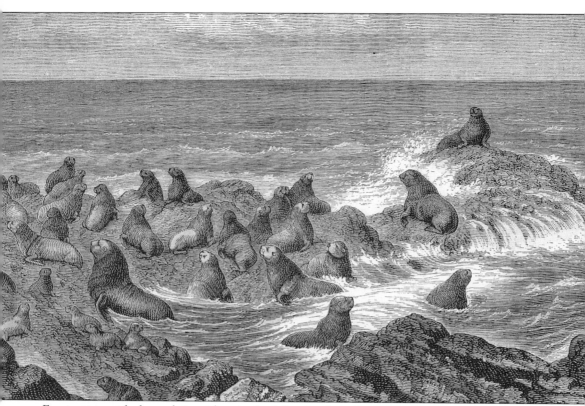

Fascination with the seals is evident in the following from *Picturesque California* in 1889: "These great roaring [*sic*], be they beast or fish, are entirely unique in action, as in utterance. They are devoted to their young and they nurse them in their arms at the breast as a mother nurses her babe, and quite as tenderly. Here the whole day through, sun or shade, storm or calm, they climb the precipitous crags, toss their huge heads to heaven and howl most dismally. And yet in all this howling there is a deep undertone of harmony, a plaintive melody which you will miss for many an hour after you return to your hotel."

Two

THE FIRST CLIFF HOUSE AND EARLY AMUSEMENTS

In 1863, local real estate man Charles Butler built the first Cliff House with a spectacular view of the Pacific Ocean and the Seal Rocks. It was an instant hit, but difficult to reach until a toll road was finished in 1864 (where Geary Boulevard is today). In 1866, the proprietor was Capt. Junius G. Foster, known as a jovial innkeeper. People flocked from the city for both good food and drink, horse racing, and other recreation. The mile-and-a-quarter "speedway" (part of the toll road) was enjoyed by such early California sports and celebrities as Hearst, Stanford, Crocker, and Ralston. In 1868 two wings were added, as well as a huge seaside balcony, to accommodate the increasing number of visitors. Thus, the Cliff House gradually became a huge tourist sensation.

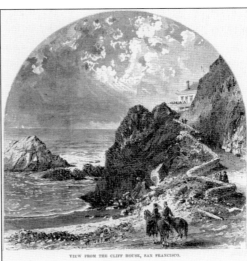

VIEW FROM THE CLIFF HOUSE, SAN FRANCISCO.

CALIFORNIA:

FOR HEALTH, PLEASURE, AND RESIDENCE.

CHAPTER I.

THE WAY OUT, AND SIGHT-SEEING IN CALIFORNIA.

THOUGH California has been celebrated in books, newspapers, and magazines for more than twenty years, it is really but little better known to the tourist—a creature who ought to know it thoroughly, to his own delight—as it was to Swift when he wrote, in his description of

2

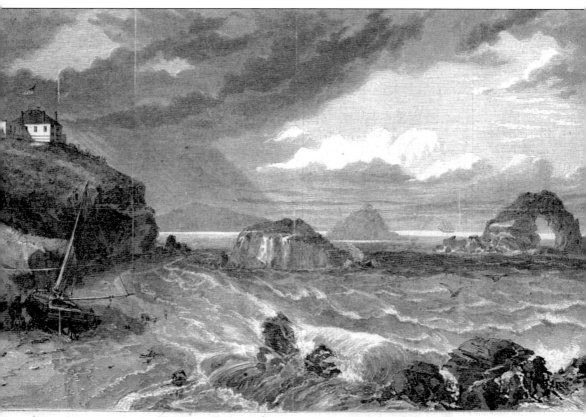

THE SEAL ROCKS AND CLIFF HOUSE NEAR SAN FRANCISCO, CALIFORNIA.

The First Cliff House, depicted in another view published in the East showing the mystique and lure of California. A wood engraving done for *Harper's Weekly* for October 26, 1867, said, "Among these rocks great numbers of seals may be heard and seen almost anytime sporting in the waves. This place is accessible from San Francisco by an excellent artificial road and is much visited by people of the city, who drive out to enjoy the entertainments of the Cliff House, to roll in their carriages over the hard beaten sea-beach where the long, smooth undulation of the Pacifica rolls and splashes softly along; or, in stormy times, to listen to the loud talking surges and doleful intonations of the seals. These animals are protected by law, their presence among the rocks being esteemed interesting. The natural aperture through the outer rock is sometimes called the "Keyhole of the Golden Gate."

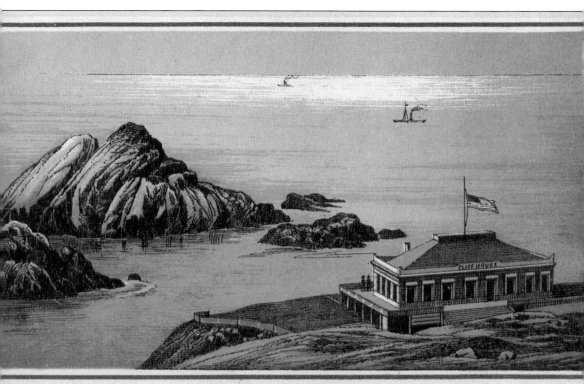

At the Cliff House.

The early Cliff House, being dwarfed by the dramatic Seal Rocks, is a beautiful view. This view was done with the photo-lithography process and appeared in a souvenir booklet, *c.* 1870, from Philip Frey & Co. Art Repository. Crowds gathered to watch such performers as James Cooke and Rose Celeste on the tight rope. In addition, a suspension bridge had been built and later abandoned when it became dangerous and after a fatal accident occurred. This was a raucous place at night where wine, women, and song were the program. Parties of revelers would often continue into the wee hours—sometimes in the upper rooms.

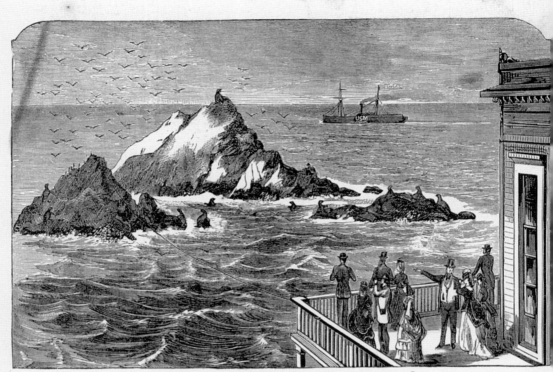

SEAL ROCKS—FROM THE CLIFF HOUSE. See page 218.

This *c.* 1875 wood engraving from *Crofuttes Overland Tourist* shows tourists enjoying an excellent view. In the ominous words of an early tourist brochure, "Failing to see the seas from the wide veranda of the Cliff House would be like visiting Rome and not seeing St. Peters." Men and women generally separated before dinner. Men went to the bar, women to the balconies to sip wine and observe the wild life.

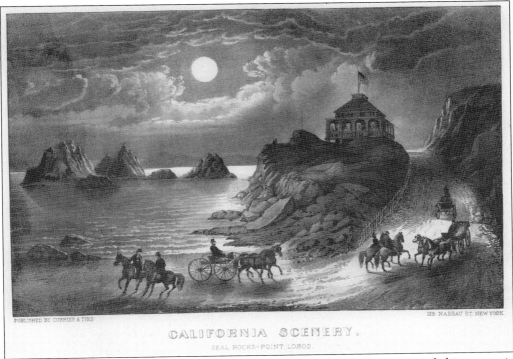

CALIFORNIA SCENERY.
SEAL ROCKS-POINT LOBOS.

PUBLISHED BY CURRIER & IVES

125 NASSAU ST. NEW YORK.

In 1859 the famous eastern lithography firm of Currier and Ives commissioned this romantic view of the Cliff House. The dramatic, hand-colored beauty of this work graced many parlor walls and helped expand the reputation of the Cliff House world wide as a tourist destination.

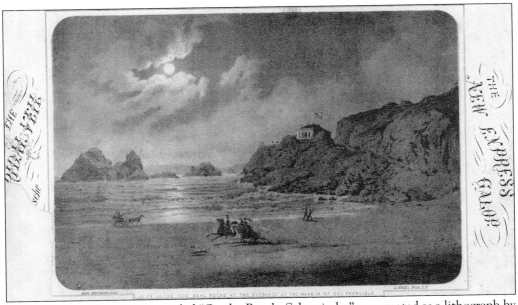

This song sheet from 1869, entitled "On the Beach, Schottische" was created as a lithograph by L. Nagel by Nahl Bros. Lithographers. The music, arranged by George T. Evans, was dedicated to the patrons of the Cliff House.

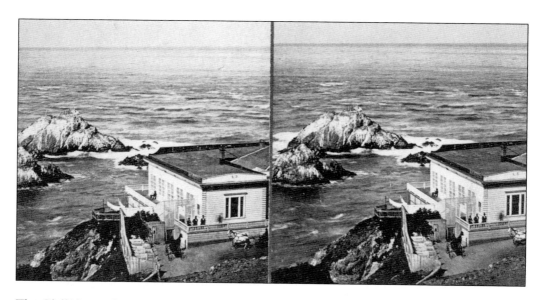

The Cliff House, Sutro Heights and the Seal Rocks at Lands End had world wide recognition and now became very popular subjects in collectibles of the era. Stereo cards are small, mounted, slightly offset photos of the same subject, which appeared as a single image when viewed through a stereopticon viewer. Tourist booklets were popular souvenirs, the one shown here, c. 1890, shows the Cliff House on its cover.

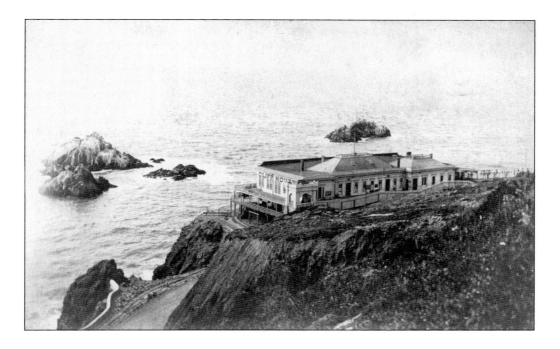

Cabinet photos also were popular collectibles. These professional photos of favored subjects were of similar sizes of ten about 8-by-5 inches mounted on a stiff cardboard backing for easy storage. These Cliff House cabinet photos were popular souveniers. Thousands of them were taken to the folks "back home."

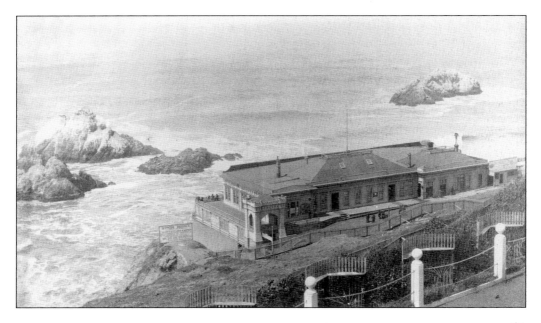

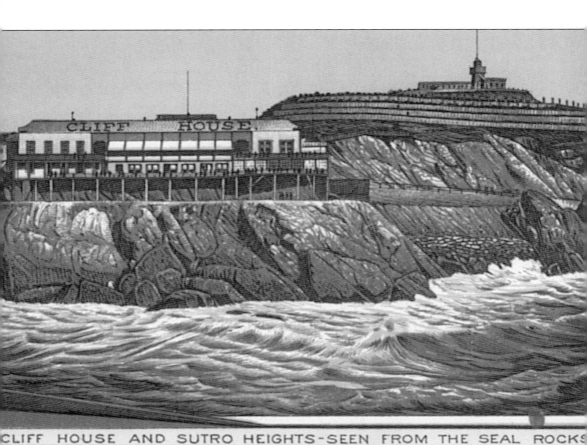

CLIFF HOUSE AND SUTRO HEIGHTS-SEEN FROM THE SEAL ROCKS

This is a photo-lithographic view of the Cliff House and Sutro Heights as seen from the Seal Rocks. This German printing process combined photography with lithography *c.* 1890. The Cliff House's reputation continued as a fun and somewhat wild place at night.

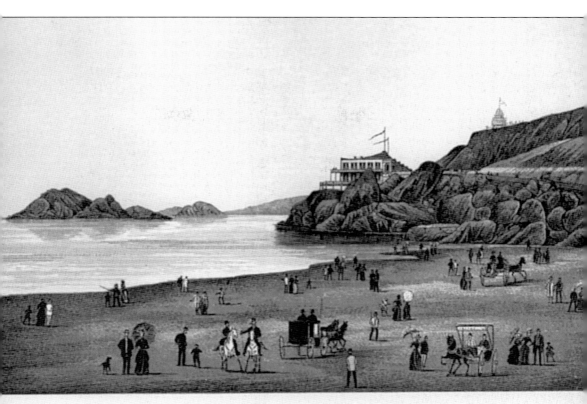

CLIFF HOUSE & SEAL ROCKS, GOLDEN GATE, CAL.

This view, from an 1888 Tourist Booklet, shows the Cliff House and Seal Rocks.

Tourists could buy a plethora of goods at the Cliff House, such as plates, dishes, ash trays, and scarves. Shown here is a plug tobacco box, c. 1890, and a cigar box label, c. 1900.

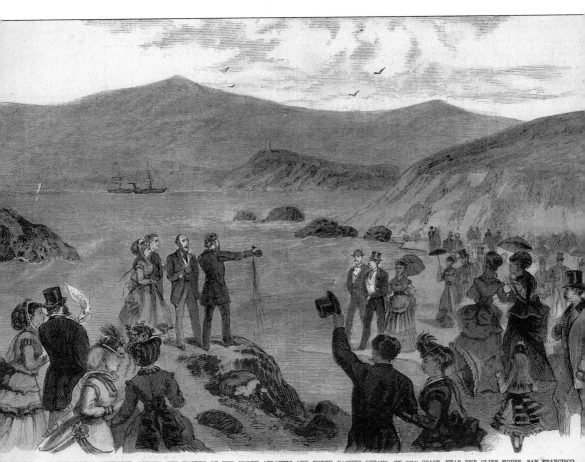

CALIFORNIA.—AN INTERESTING CEREMONY—MIXING THE WATERS OF THE NORTH ATLANTIC AND NORTH PACIFIC OCEANS, ON THE COAST, NEAR THE CLIFF HOUSE, SAN FRANCISCO. FROM A SKETCH BY FRANK H. SHAPLEIGH.

This wood engraving, from *Frank Leslie's* in 1870, illustrates the mixing the waters of the Atlantic and Pacific. The article read in part, "Several weeks ago, a large party of influential gentlemen of Boston, with their ladies, started on a special train of palace cars for a trip to and from San Francisco, Cal., by the way of the Union Pacific Railroad. Just previous to the departure of the excursionists, one of the party filled a large bottle with water from the Atlantic Ocean, and had it carefully packed for a ceremony of considerable interest and novelty. On their arrival at San Francisco, the party descended to the beach, the bottle of water being carried at the head of the procession. Position was taken on a rock out among the breakers, and Honorable Alexander H. Rice officiated as master of ceremonies. Taking the bottle, he poured half of its contents into the Pacific, then refilled with Pacific water. A witness gravely asserted that there was no visible effect to be seen, either in the vast expanse of water before them, or the small quantity contained in the bottle. The two liquids mixed with an astonishing degree of naturalness. The party cheered with the utmost enthusiasm, hats were swung, handkerchiefs waved and Boston and San Francisco clasped hands, were happy, and united in singing 'America.' Returning to the hotel, the party again organized, and the bottle of mixed waters was passed around the circle. Cheers were given for Massachusetts, California, Boston and San Francisco. An American flag was placed on a table inside the ring, and cheers were given for the Stars and Stripes. Next, a San Francisco production, in the shape of a little girl, was brought forward, and christened May Elizabeth Brown by Rev. Mr. Waterson, who sprinkled the child with the mixed water. This closed the ceremony and visit, and the party again taking to their carriages returned to the city."

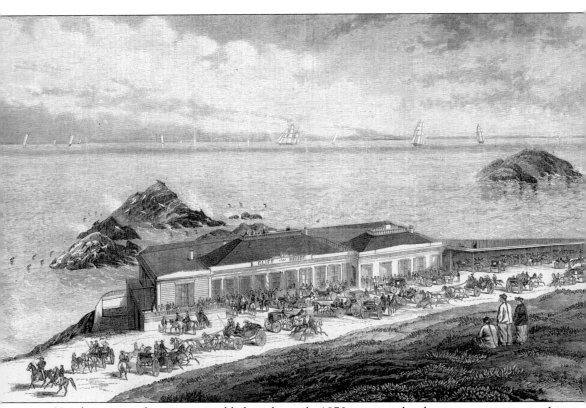

Hotel accommodations were added in the early 1870s, as seen by the two new wings in this wood engraving from *Frank Leslie's* in June of 1870. By the middle of this decade the impact of tourism was increasingly being felt. On crowded weekends, people from town often could not even find a spot to park their rig, and so they would have to turn around and go back.

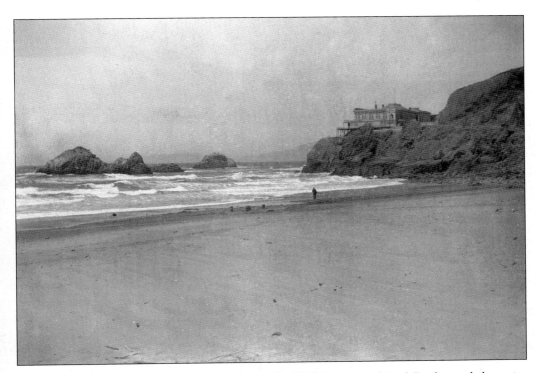

In these c. 1880 view, one can see Ocean Beach, Cliff House, and Seal Rocks, and the quite rugged road below Sutro Heights. In the 1880s the Cliff House again gained a notorious reputation for gambling and other illegal activities.

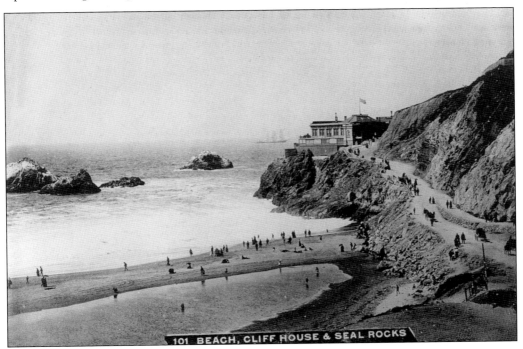

101 BEACH, CLIFF HOUSE & SEAL ROCKS

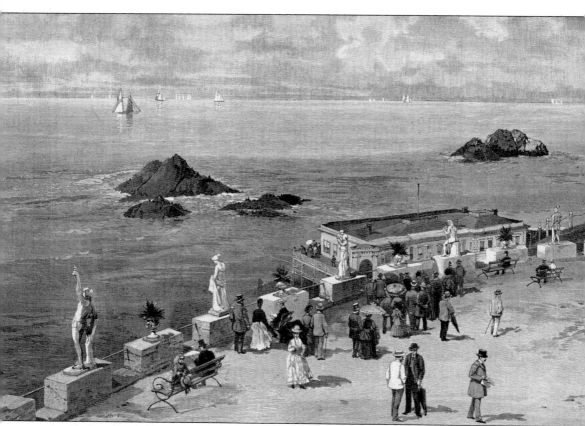

In 1881 Adolph Sutro bought the property and decided to clean up its image. This stylish 1887 wood engraving by Charles Graham, world-renowned staff artist for *Harper's Weekly*, shows the "new" Cliff House. Sutro went so far as to build a railroad from town to make it easier for people to visit. In 1887 tragedy struck when the *Parallel*, a ship loaded with dynamite, crashed into the rocks below. The ensuing explosion was felt for miles and resulted in severe damage. In 1894 the whole structure burned down.

Three

SUTRO AND
SUTRO HEIGHTS

Adolph Sutro impacted Ocean Beach certainly more than any other single person. Emigrating from Prussia, he used his business acumen and entrepreneurial skills to amass a fortune. After selling his self-devised mining tunnel in the Comstock Lode, he devoted himself to buying San Francisco real estate. At one time he owned $1/12$ of the City. He was a generous man and believed that the human condition could be elevated with education. Adolph Sutro first visited the Heights in 1879 while on a carriage tour of the park with his daughter. He promptly fell in love with the area and eventually built a mansion, a conservatory, and a park for all the world to visit.

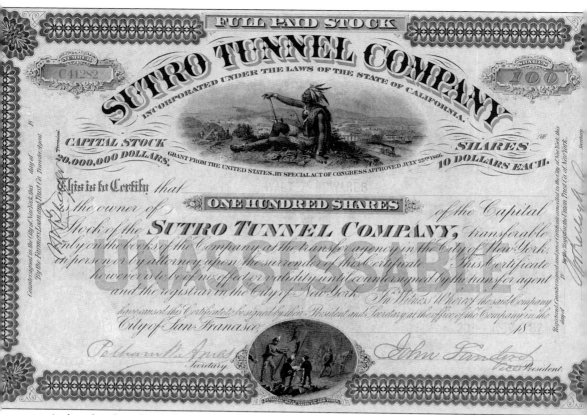

A decade after the California Gold Rush, miners rushed to open newly discovered lodes of gold and silver around Virginia City, Nevada. In 1859, Sutro (a San Francisco tobacconist too) went to the "Comstock Lode" to join the rush. During the years he spent in Nevada as a mine operator, he witnessed the difficult conditions under which the miners worked including the heat and the flooding problems. He envisioned a tunnel which he named after himself and proposed to build. It solved the problem of drainage and ventilation. He raised money through the Sutro Tunnel company and the tunnel was created. He eventually sold out and returned to his beloved city of San Francisco as a major financial nabob.

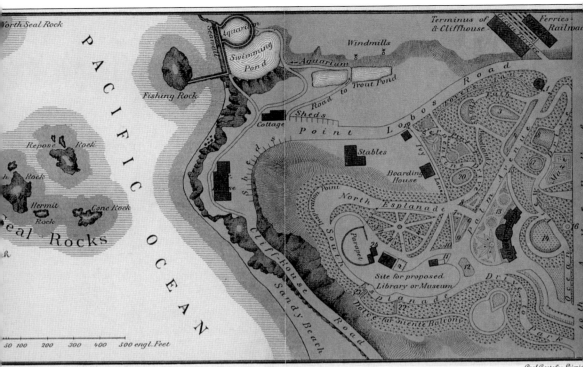

PLAN OF SUTRO HEIGHTS, CLIFF HOUSE & SEAL ROCKS.

This is an 1889 plan of Sutro Heights. Visiting the area in 1880, Sutro envisioned the possibilities of this magnificent spot, not only for his family, but also the citizens of San Francisco. His knowledge and love of botany, art, and literature was reflected throughout. Most importantly, the grounds were open free to the public. The inhabitants of Seal Rock had a special place in his affections. Prominent men of the day were immortalized as the sea lions "Benjamin Butler" and "Benjamin Harrison Cleveland." When fishermen wanted the seals exterminated, Sutro was instrumental in securing legislation for their permanent protected status.

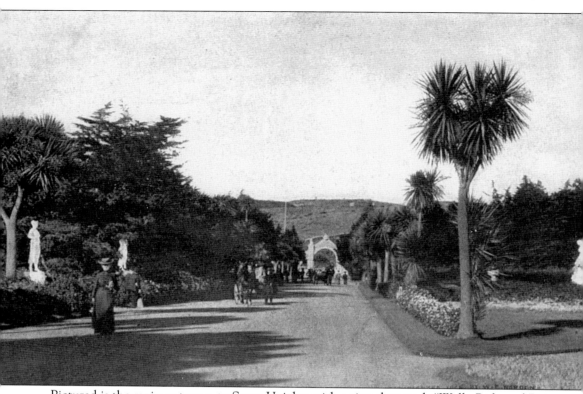

Pictured is the main entrance to Sutro Heights with a sign that reads "Walk, Ride and Drive Therein." Palm Avenue, the main avenue in Sutro Heights, was lined with statues, palm trees, and flowers.

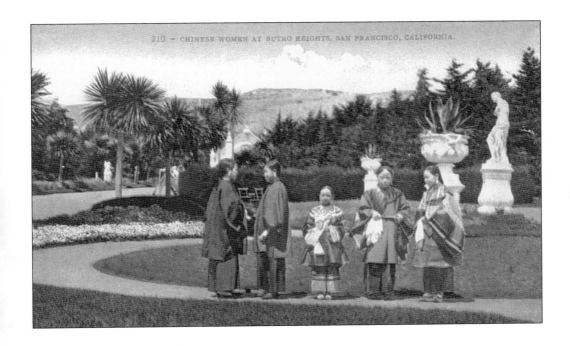

Sutro's love of botany was reflected everywhere on the grounds. Sutro planted hundreds of Australian eucalyptus, fast-growing Monterey pine, and other varieties of trees. He spent $1 million on improvements, added a stable for thoroughbred horses, and employed 15 caretakers, scores of gardeners, and a corps of house servants.

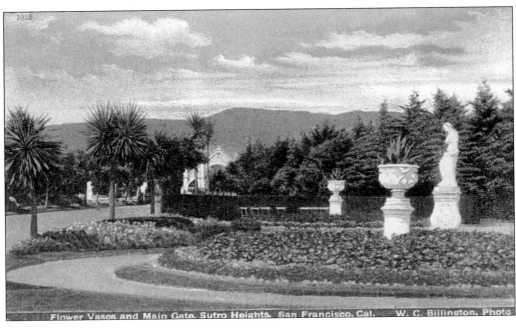

33

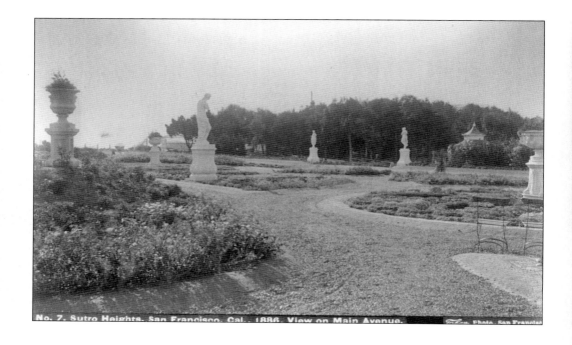

No. 7. Sutro Heights. San Francisco. Cal.. 1886. View on Main Avenue. *Taber* Photo. San Francisco

Shown are two more views of the gardens on the grounds at Sutro Heights. (Courtesy of Taber Photos.)

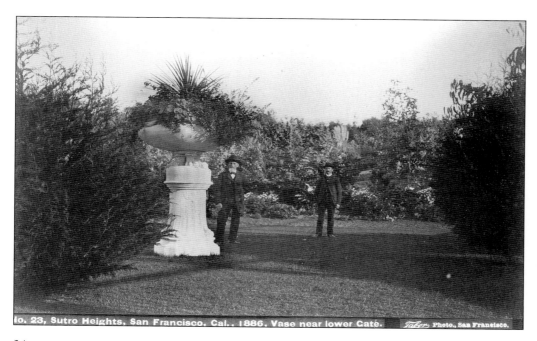

lo. 23, Sutro Heights, San Francisco. Cal.. 1886. Vase near lower Gate. *Taber* Photo., San Francisco

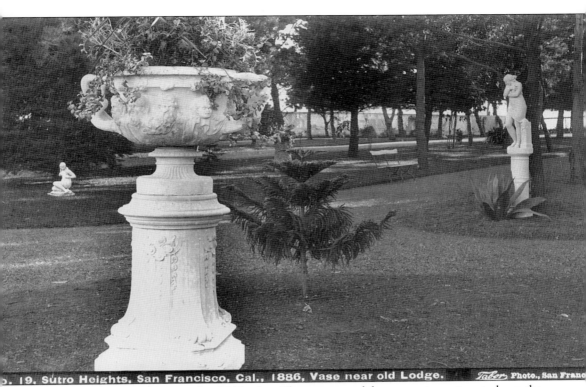

19. Sutro Heights, San Francisco, Cal., 1886, Vase near old Lodge. *Taber* Photo., San Franc

This photo shows a vase near the Old Lodge. There was an elaborate water system to keep the grounds green. Water drawn from springs was pumped by a windmill to a reservoir where it was gravity-fed to the conservatory, fountains, and house. (Courtesy of Taber Photos.)

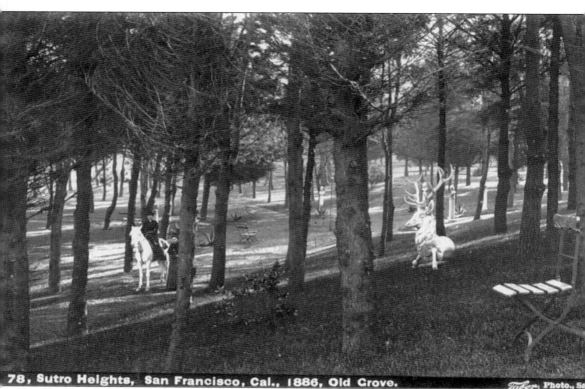

78, Sutro Heights, San Francisco, Cal., 1886, Old Grove. Taber, Photo., Sa

Emma was Sutro's eldest daughter (one of six children). She was riding with her father when they fell in love with the Heights. Here, in an 1890s photograph, she is seen riding horseback on the grounds. Later she attended a medical school built on land donated by her father—today's UCSF medical center. The property was deeded to the city in the 1920s and she lived in the house until her death in 1938. (Courtesy of Taber Photos.)

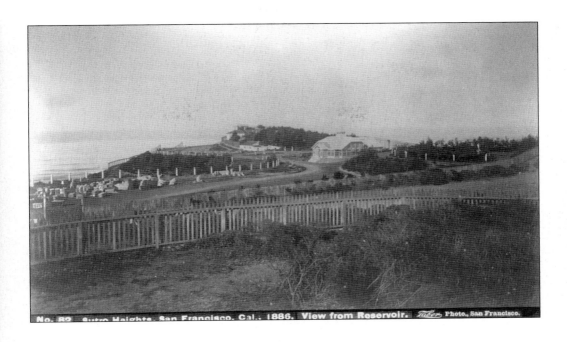

No. 82. Sutro Heights. San Francisco. Cal.. 1886. View from Reservoir. *Taber* Photo., San Francisco.

Two views of the conservatory on Sutro Heights can be seen here; Sutro is shown in his top hat riding the carriage though the grounds. Sutro, with his artistic sense and knowledge of botany, created a paradise from a sandy wasteland. The winding walks, the groves, the fragrant shrubs and flowers, and the lawns were open to the public. Plants from all over the world were grown in the conservatory including exotic orchids.

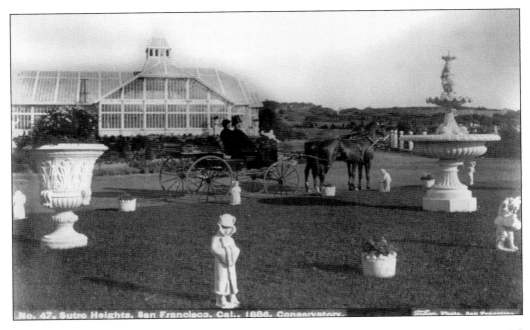

No. 47. Sutro Heights, San Francisco. Cal.. 1886. Conservatory. *Taber* Photo., San Francisco.

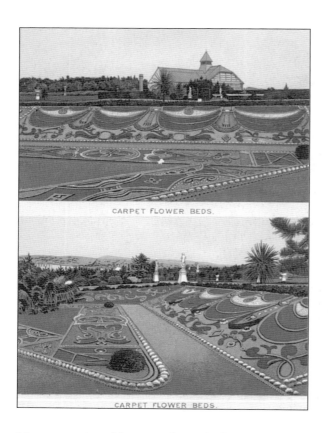

CARPET FLOWER BEDS.

CARPET FLOWER BEDS.

More examples of dramatic flower beds, kept up by numerous gardeners, are seen in this view. The flower beds were scattered throughout most areas of the grounds.

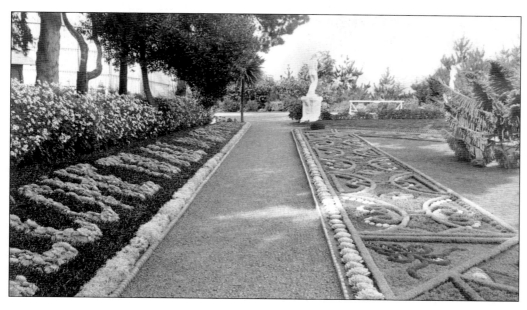

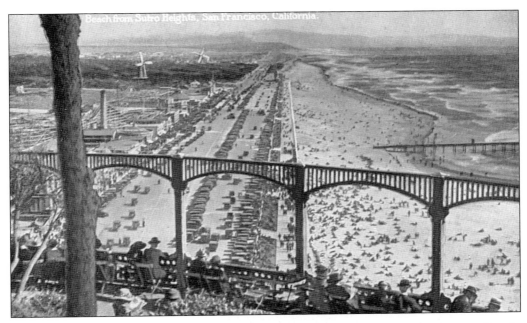

Laura Ingalls Wilder, author of *Little House on the Prairie*, while visiting the Panama Pacific International Exhibition in 1915, said in a letter home about Sutro Heights, "We went from there out on the edge of the cliff where there are seats and statues around the edge and one can sit or stand and look over the ramparts across the blue Pacific. An America eagle in stone stands screaming on the edge at one side. Two cannons were in place pointing out to sea and there were several piles of cannon balls. I kicked one to be sure it was real—and it was. The winds off the ocean are delightful." The sitting area pictured here is called La Dolce Far Niente ("Sweet to do Nothing") located 200 feet above the beach. It was a focal point with a sweeping and majestic view.

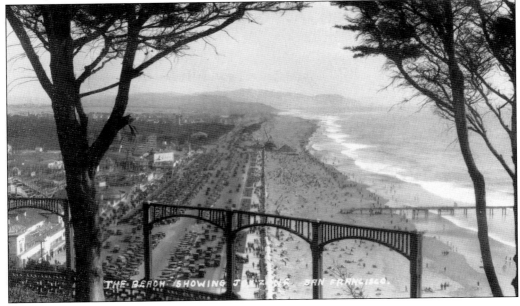

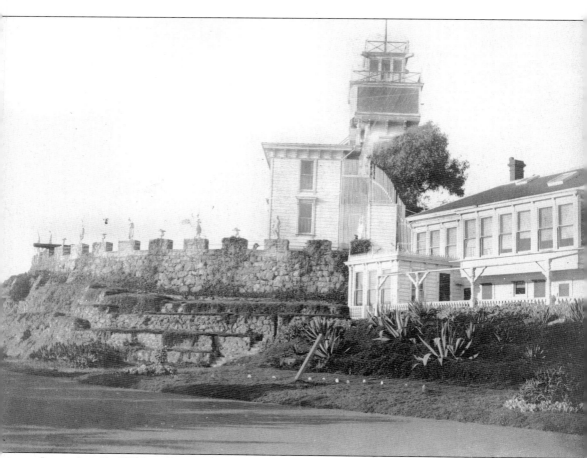

Laura Ingalls Wilder also wrote of Sutro Heights, "The whole front and side of the house is glass so that one would have the view from every point. The pillars of the balcony have (Delft) porcelains inset, as do the posts of the stone fence around the house. They are small squares as smooth and glossy as my china, with quaint old-fashioned pictures of children and animals, instead of the flowers on my dishes. Close beside the house is a very tall slender building, and observatory with a glass room at the top where the family used to go to watch the ships come in through the Golden Gate."

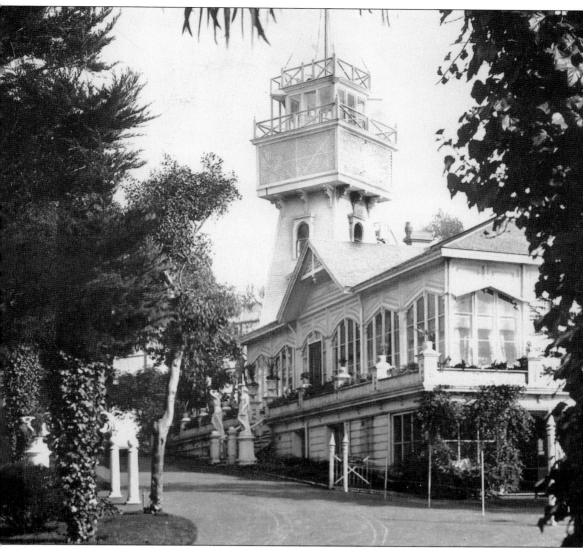

This *c.* 1894 glass negative shows a view of Sutro's house with its glassed-in porch and observatory. The original house was a modest structure sitting on $1^1/_2$ acres—"The Samuel Jetlow House." Sutro first acquired 20 additional acres of land and expanded the structure with several rooms and a glassed-in porch. In 1886 he added the observatory. Sutro could have torn the original building down and constructed a magnificent mansion as other millionaires did. Instead, he spent a fortune developing the extensive gardens, stables, outbuildings, and magnificent gardens.

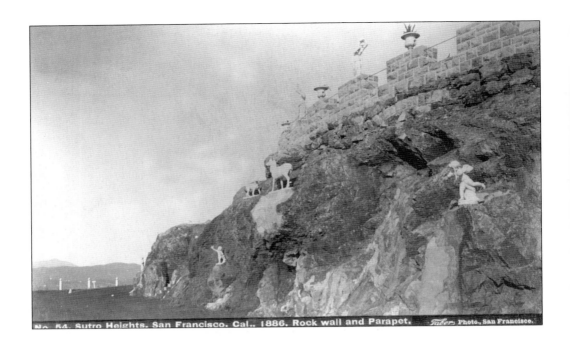

No. 54. Sutro Heights. San Francisco. Cal.. 1886. Rock wall and Parapet. Taber Photo., San Francisco.

The cliff below the parapet also had statuary. (Courtesy of Taber and Billington.)

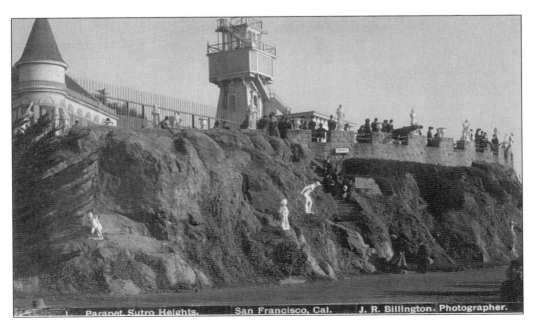

Parapet, Sutro Heights. San Francisco, Cal. J. R. Billington. Photographer.

42

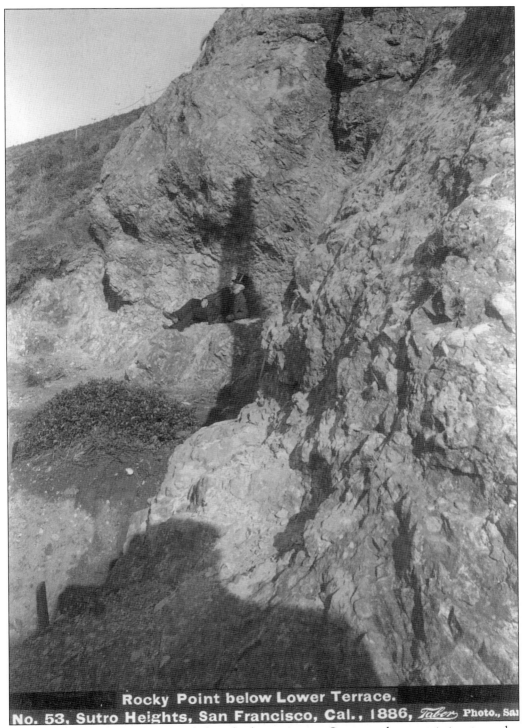

Rocky Point below Lower Terrace.
No. 53, Sutro Heights, San Francisco, Cal., 1886, *Taber* Photo., San

This view shows the rocky point below the lower terrace. Sutro can be seen sitting on rocks.
(Courtesy of Taber Photos.)

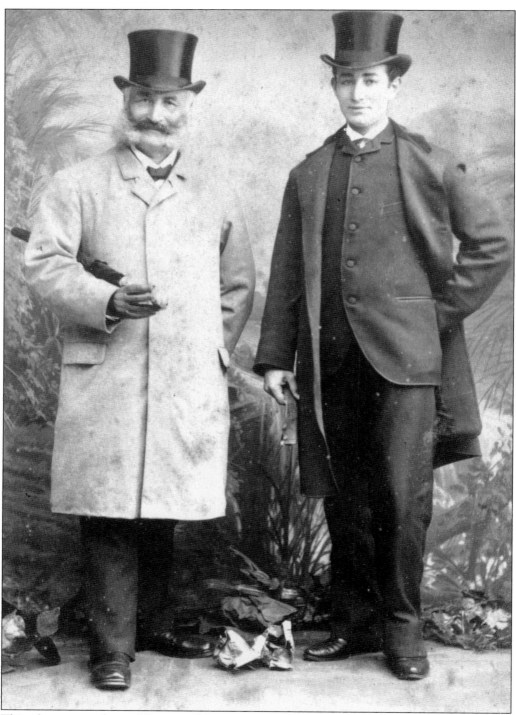

This photo was taken of Sutro and his son Charles on a trip they took to Europe. Sutro's trademark sideburns covered scars from a knife attack. He was a fastidious man who travelled with his own collapsible bathtub.

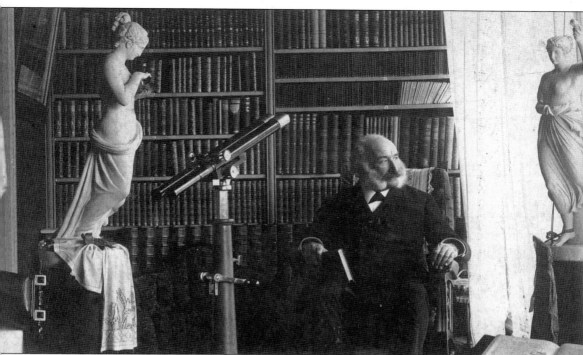

Sutro maintained a private library, which was said at the time to be the largest private collection in the United States. He had begun obsessively collecting books and art objects on his trips to Europe. These collections filled his homes and gardens. Sadly, about half of the library was lost in the earthquake and fire of 1906. Sutro's heirs gave the collection to the California State Library in 1913, and it can be viewed today at the Sutro Library in San Francisco.

This 1897 broadside advertising brochure offered lots for sale near Sutro Heights for just $25 down, and $10 a month.

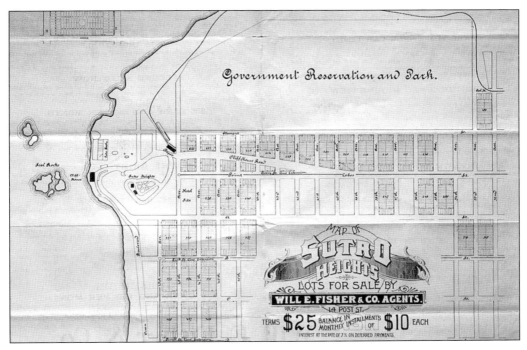

Another 1893 real estate broadside for Sutro Heights offered lots directly from Adolph Sutro.

SUTRO HEIGHTS

Sutro Heights is so well known to every resident of San Francisco that the offering of this tract is sure to find many buyers. A glance at the map will show its importance either for speculation or residence.

ALL THE CABLE CAR LINES

Are building to the property. Two steam car lines now in operation,—"D" street is being graded preparatory to track-laying by the Powell-Jackson street line. Surveys are completed on "B" street for the extension of the Turk street line to be operated by electricity.—The Geary Street Co. will commence the construction of an electric extension on Geary street to the Cliff House, making these lots eligible by five lines of cars.

UNSURPASSED MARINE VIEW

Gradually rising from "D" street on the South to the "Bluffs," every foot of the property commands a Marine View of exceeding grandeur. It was the Marine View that made Pacific Heights property advance in five years to $400 per front foot. The advance of property on Sutro Heights will be even more rapid than it was on Pacific Heights.

Lots are for sale on the liberal terms of

$25 CASH AND $10 PER MONTH,

Interest on deferred payments 7 per cent.

INVESTMENT IN REAL ESTATE

To be successful is governed by three things,—Railroad Communication, prospect of advance and location.

SUTRO HEIGHTS

Possesses all these requirements. Already reached by two lines of steam cars with three others building, these lots are very near to the business centers. The location is the best in the City and is destined to become the homes of the wealthy and the refined. The streets being macadamized and the lots already graded will result in the immediate building by buyers, thus causing a rapid increase in values

HINTS TO BUYERS.

Successful operators in real estate in this, as well as in other cities, follow the fixed principle of buying only in those sections to which railroads are building, and they always make money.

Railroads never build to any location that is not sure to build up rapidly. All the cable lines are constructing extensions to this property, and very soon the same advance will occur which has always followed the extension of the railroads to other sections.

HOMES ON THE INSTALLMENT PLAN.

Purchasers of lots can make arrangements to have houses erected on a system of easy monthly payments.

NOTE: 47th Avenue is the macadamized driveway to Sutro Heights from the Park.

$30 PER MONTH.

will in six years amount to nearly $2350, including interest, all of which is lost by the party who rents, whereas he who buys a home on the installment plan is just that amount ahead besides the advance in value, which will amount to at least $1000 more.

IT IS INCREDIBLE

That people will go on year after year throwing money away in rent when they could just as easily save it. By far the largest number of real estate owners in San Francisco to-day are they who originally bought on the installment plan.

SECURE A LOT NOW.

When this tract is sold, the last chance to buy on the installment plan will have passed, because this is the last of the great holdings, and in future it will take more money to buy lots. The payments are easy and will never be felt.

$25 CASH AND $10 PER MONTH.

To make a fortune in real estate, a man must possess foresight enough to buy in the right city and in the right part of that city.

THERE IS NO SURER WAY

To grow rich than to use lots in a thriving city as a savings bank and to put into them the savings which result from a life of industry.

THE RIGHT CITY.

San Francisco is growing with a steady and uniform growth. In five years we will have 400,000 inhabitants. The State is rapidly growing, which means industrial and commercial development of the city.

THE RIGHT PLACE.

Sutro Heights possesses the following advantages which demonstrate it to be unquestionably the right place :—

The railroads are building to it.

The trend of population is altogether in that direction. The Marine View is the best in the State. The streets are macadamized and a number of first-class residences will be erected immediately.

Among the improvements contemplated is a hotel costing $1,000,000 exclusive of furniture. The Sutro Baths will open January 1st and will attract many people. Sutro Heights front on Golden Gate Park.

Macadamized Streets, Sewers, Water, Gas and Electric Lights all ready to connect with your house.

REMEMBER,

$25 CASH AND $10 PER MONTH.

Interest 7 per cent. We are pleased at all times to have you call at our office for further particulars and will take you to see the property at any time suitable to your convenience.

Will E. Fisher & Co.

REAL ESTATE AGENTS AND AUCTIONEERS,

Sutro was said to have planted one million trees in San Francisco, and apparently he had a few extra, because plants could be bought from the head gardener at Sutro Heights.

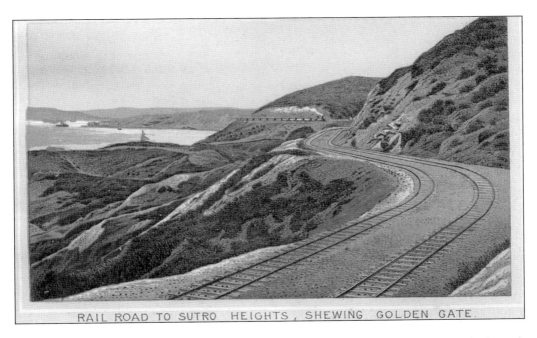

RAIL ROAD TO SUTRO HEIGHTS, SHEWING GOLDEN GATE.

Around 1890, there were three popular ways to get to Sutro Heights. The carriage ride through Golden Gate Park from the city to the ocean, the 10¢ railroad trip from Park Beach and Cliff House Railroad (this route started at the entrance to Golden Gate Park through the park to Ocean Beach and up the windy road to Sutro Heights), and via the ferries and Cliff House Railroad, which started at Central Avenue and cut along bluffs by the Golden Gate. The latter route was noted for its beautiful views along the way.

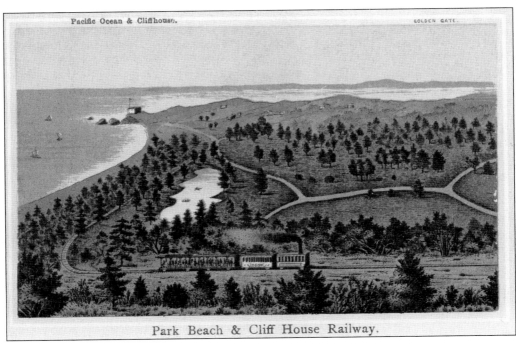

Park Beach & Cliff House Railway.

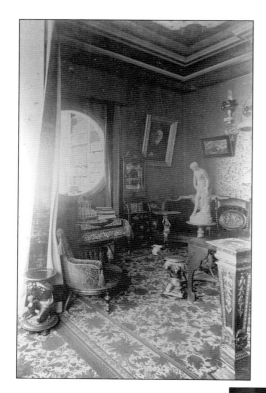

The drawing room inside Sutro's Mansion shows typical Victorian decoration. The house was filled with bric-a-brac, statuary, gilded frames, and carved furniture. (Courtesy of Taber Photos.)

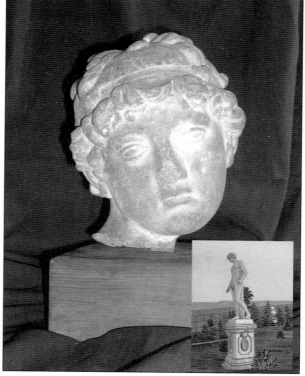

After Sutro's death, the house and grounds gradually deteriorated. They had been deeded to the city in the 1920s to be kept "perpetually as a place of public resort." The house was torn down in 1939. In the 1960s, the last remains of the house at Sutro Heights were demolished. The head shown here was saved from a dumpster; it was originally the statue *Antinous* as shown in this 1890 lithograph.

Four

SUTRO BATHS

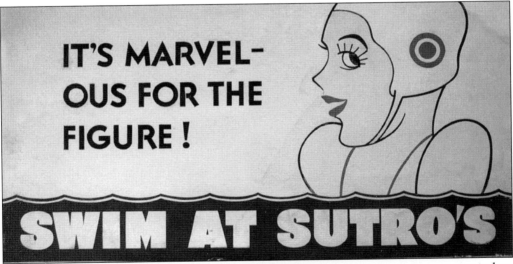

Adolph Sutro built a pleasure palace for the citizens of San Francisco; it was an enormous indoor bathing area—the largest in the world. There were six saltwater pools and one freshwater pool, each with different water temperatures. Ocean water was captured in tidal basins, heated to different temperatures, and pumped into the salt water pools. Over 10,000 people could be accommodated in the complex at one time. The baths served as a learning center as well, with museum collections to view as well as circus acts, bands, games, and contests. In 1896 it officially opened its doors to the public. It cost 10¢ to get in, and 25¢ to swim.

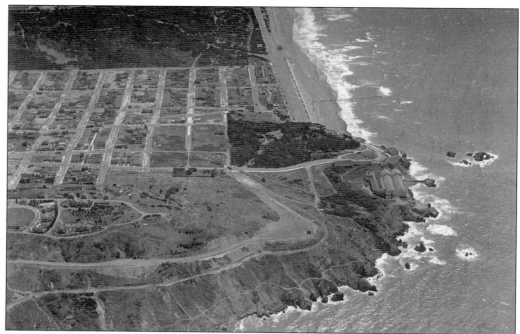

This aerial view shows Sutro Baths in relation to Sutro Heights and Seal Rocks. (Courtesy of Staples Photo.)

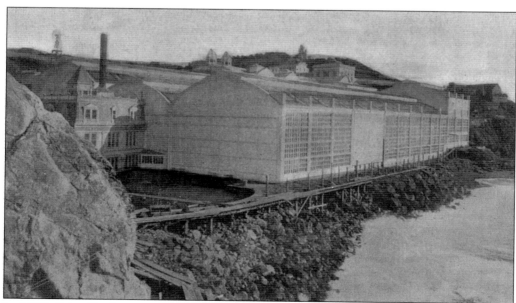

In 1899, *Scientific America* called the baths "The most enduring monument to the memory of Adolph Sutro . . . great ingenuity has been exercised in emptying the baths with the most advanced ideas on sanitary engineering . . . great ingenuity has been shown in protecting the baths with a massive break water (450,000 cubic feet of rocks)." Of further note, the magazine said, "The tanks have an ocean frontage and the buildings being of iron and glass, bathers can see and hear the breaking waves."

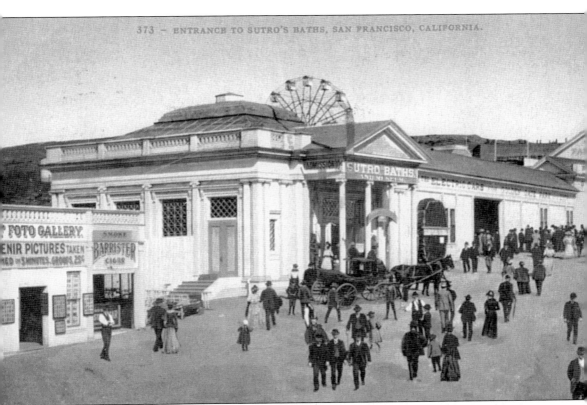

Fun seekers entered the Baths through Grecian columns. Next door was the Foto Gallery where tourists could get photos taken with various backdrops such as the Cliff House and Ocean Beach. Samples were on display out front. In the background the top of a Ferris wheel can be seen—a big sensation since its introduction at the Columbian Exposition in Chicago in 1892.

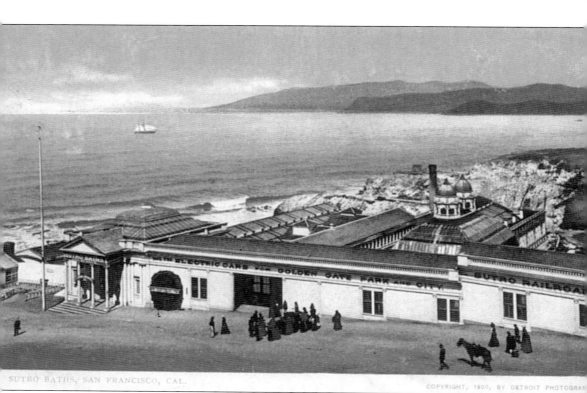

Seen here is a different entrance to Sutro Baths and the railroad barn in the 1890s. The railroad cars came into the barn, where patrons alighted and went into the baths. This electric railroad, created by Adolph Sutro, was a cheap method of transportation for the average person. Note the ship in the background approaching the Golden Gate and San Francisco Bay.

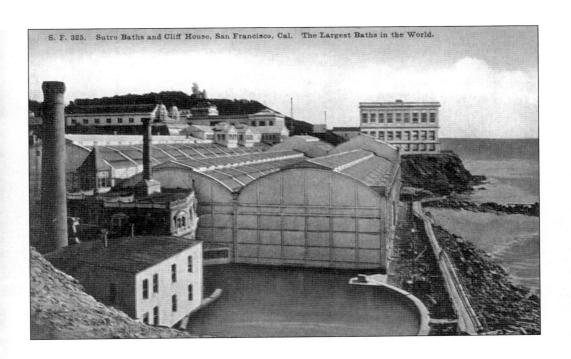

S. F. 325. Sutro Baths and Cliff House, San Francisco, Cal. The Largest Baths in the World.

This exterior view of the Sutro Baths shows the grand Cliff House in the distance. In the 1920s, there was a walkway out to the rocks.

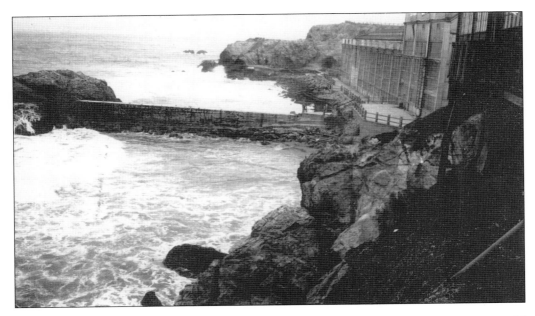

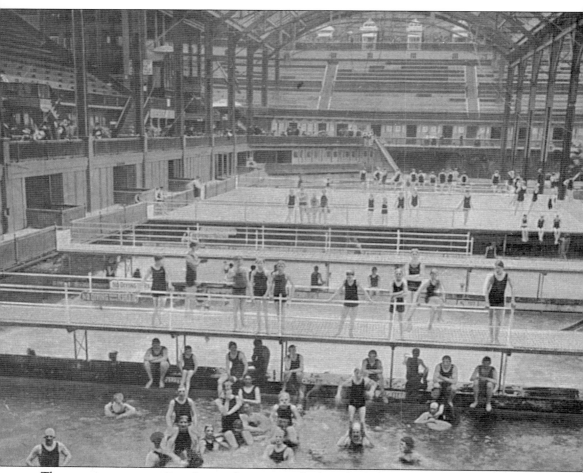

The structure was massive. It was three stories high. It had 500 dressing rooms. This picture shows the enormous glass enclosed pool area with its grandstands. Iron girders supported a ceiling of glass which promoted the feeling of being outdoors.

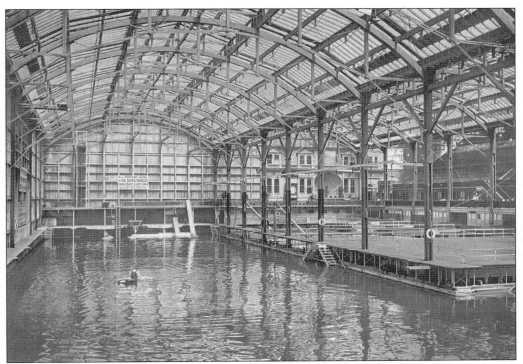

The two-acre roof had 1,000 panes of glass. The sign in the background reads, "All persons using high dives, trapezes, spring boards, slides and rings do so at their own risk." (Courtesy of Detroit Photographic Co.)

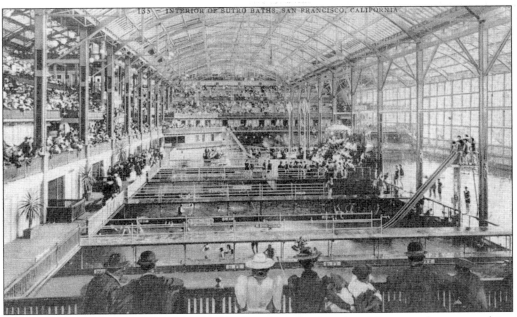

Sutro was a strong believer in the health benefits of swimming. Here people are watching healthy habits being cultivated on a giant water slide.

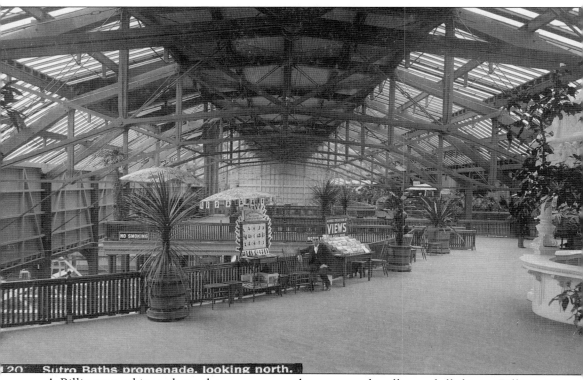

A Billington cabinet photo shows a man on the promenade selling, of all things, Billington cabinet photos. These lovely promenade areas were also used to display museum items and collections, since Sutro liked to instruct as well as entertain. A 1910 appraisal of the Baths mentions such items as: stuffed polar bears, walruses, sea lions, foxes, and mammals. There were 60 parrots, stuffed fish, and mounted insects as well as paintings, statues, flora, and fauna. Exhibits included Japanese and Mexican items, Egyptian coffins and mummies, Esquimaux and American Indian baskets, clothing, and curios.

Here we can see a typical weekly program of events at Sutro Baths: "Sunday June 27, 1897: Bathing from 7am—5pm. "No better sea bathing in the world—temperatures up to 80 degrees. On Sunday—Mullin Sisters, cornet duet, three legged swimming contest, 50 feet back swimming race, the Ordways—world championship trick bicyclists and an underwater swimming contest. On Tuesday, Wednesday, Thursday, Friday and Saturday—music by the Gauloise Band with a full musical program. Notice for upcoming 4th of July event "The Doll Fairy"—one hundred beautiful girls in a bewildering and gorgeous display of costumes, grand chorus of one hundred voices, cornet duet and solos by the celebrated Mullin Sisters, grand finale of superb historical tableaux."

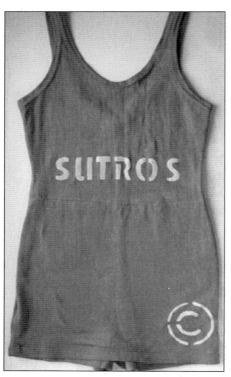

This is an original all wool swim suit, possibly itchy, worn by all the bathers. An inside pocket held a changing room key. There were 500 changing rooms and laundry facilities to wash thousands of bathing suits every day.

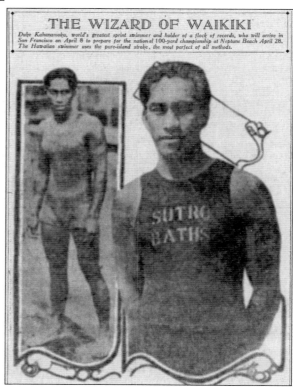

THE WIZARD OF WAIKIKI

Duke Kahanamoku, world's greatest sprint swimmer and holder of a flock of records, who will arrive in San Francisco on April 8 to prepare for the national 100-yard championship at Neptune Beach April 28. The Hawaiian swimmer uses the pure-island stroke, the most perfect of all methods.

Wearing his Sutro bathing suit is the "Wizard of Waikiki"—Duke Kahanamoku, the champion swimmer and surfer.

Pacific Coast Bath House Association

The primary object of the Bath House Association is to assist its members in maintaining high and uniform standards of safety and sanitation.

The water in this plunge is periodically subjected to rigid tests by the California State Board of Health and also by qualified experts.

In order to maintain proper standards and protect the health of patrons, it is necessary to insist upon the observance of the following rules, which have been approved and their strict enforcement required by the

CALIFORNIA STATE BOARD OF HEALTH

Rules for Bathers

1. All bathers shall use shower baths, including soap if necessary, before entering plunge. (The plunge is not intended as a bath tub).

2. Bathers who have been outside the bath house or plunge enclosure shall not re-enter without passing through a foot bath and using shower.

3. Bathers shall be forbidden to wear private bathing suits that are improperly laundered and sterilized.

4. Women shall wear caps while in plunge.

5. Persons not dressed for bathing shall not be allowed on walks surrounding plunge, and bathers shall not be allowed in places provided for spectators.

6. No person suffering from fever, cold, cough or inflamed eyes shall be allowed use of plunge. (These disorders are contagious).

7. No person with sores or other evidence of skin disease, or who is wearing a bandage of any kind, shall be allowed to use plunge. (A bandage may conceal a source of infection).

8. Spitting in, or in any other way contaminating the plunge, and spitting on floors, runways, aisles or dressing rooms, shall be prohibited. Use scum gutter provided for that purpose.

9. Public combs or brushes shall not be furnished, and such articles left by bathers shall be permanently removed.

10. Eating within the plunge enclosure shall be prohibited.

11. Bringing or throwing into the plunge of any objects that may in any way carry contamination, endanger safety of bathers or produce

The Sutro Baths had posted rules for bathers, including the following: "All bathers shall use shower baths, including soap if necessary, before entering the plunge. (The plunge is not intended as a bath tub) Spitting in, or in any other way contaminating the plunge, and spitting on floors, runways, aisles or dressing rooms, shall be prohibited. Use scum gutter provided for that purpose Public combs or brushes shall not be furnished, and such articles left by bathers shall be permanently removed."

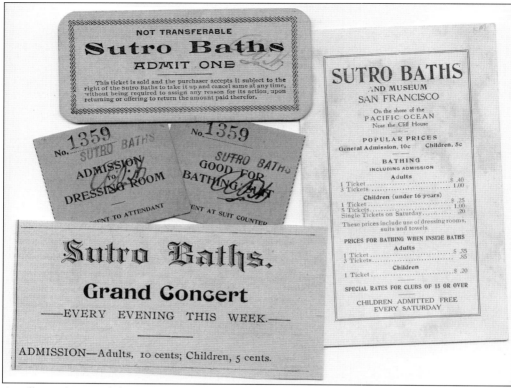

A collage of some of the various tickets and promotional items for the Baths can be seen here.

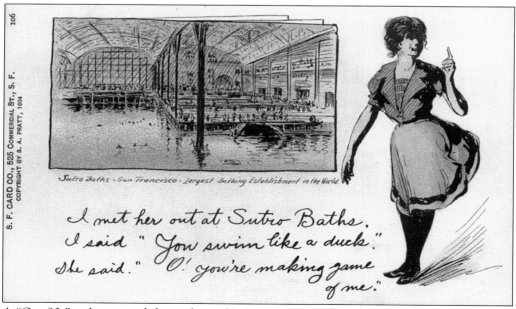

A "Gay 90s" style postcard shows the sophisticated humor of the day.

SUTRO ◆ BATHS

☞ **$1000 IN PRIZES** 🖐

GRAND INTERNATIONAL

TUG OF WAR

GREATEST CONTEST EVER SEEN HERE!

Two Afternoons: Sundays, Dec. 13th and 20th.
Seven Nights: December 13th to 19th inclusive.

ALL TEAMS will contest at EVERY PERFORMANCE.

Admission, 25 Cts. Reserved Seats, 50 Cts.

Sutro Baths

Sunday, July 3d, at 2:30 P. M.
Monday, July 4th, at 3. P. M.

Grand

Aquatic
Carnival

IN WHICH THE

VOLUNTEERS

〜〜 FROM 〜〜

Colorado, Kansas, Tennessee, Minnesota,
Washington, California, Nevada,
Nebraska and Montana will participate.

ADMISSION 10 Cts. CHILDREN 5 Cts.

Sutro Baths

SUNDAY, AUG. 14, '98

World's Championship

220 Yds. Swimming Race

BETWEEN

SIDNEY CAVILL
Australian Champion

—AND—

R. B. CORNELL
Pacific Coast Champion

For a Purse of **$500**

Also Immense Aquatic Programme.

ADMISSION 10 CTS. **CHILDREN 5 CTS.**

These broadsides show some of the wide variety of activities available at the Baths.

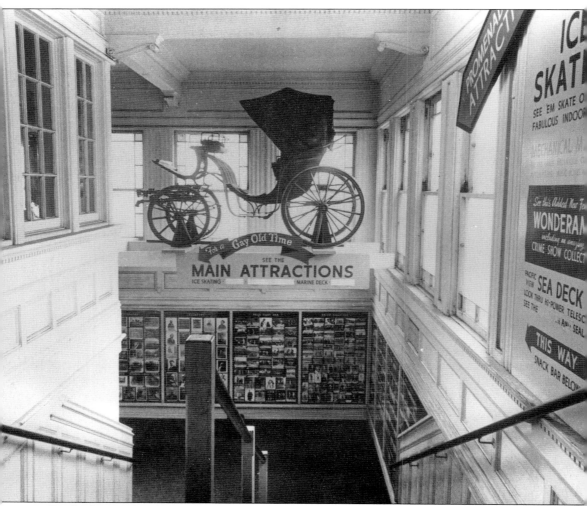

By the late 1950s the pools were all closed but the sign welcoming visitors still proclaimed: "For a Gay Old Time, See the Main Attractions." By now, these were ice skating, a sea deck to view the seals and ships through a telescope, dancing, and museum collections.

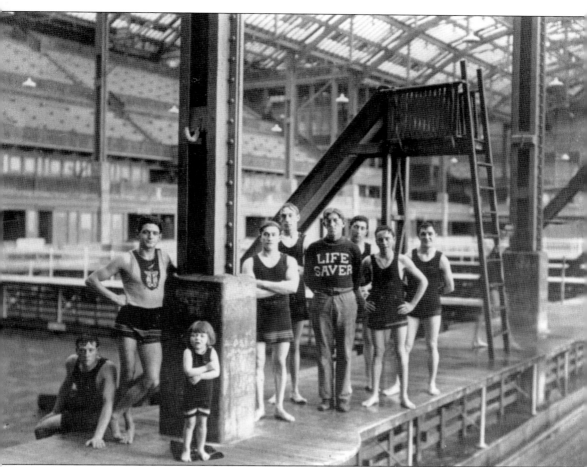

Lifesavers and swimmers are taking a break in this 1915 photo. They are standing on a pier between two pools. Behind them is the ladder to one of the giant water slides. In the background is a good view of the spectacular stands and the massive glass roof. (Photo Courtesy of San Francisco History Center.)

SUTRO BATHS

Tropical WINTER GARDEN
CONCERT DAILY

FREE SWIMMING LESSONS
TO ALL BATHERS

Extra Attractions Sundays
Admission 10c. - Children 5c.

In the 1930s, Sutro Baths began offering ice skating in the winter to attract crowds.

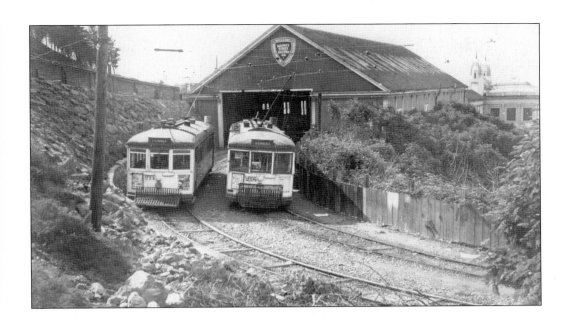

As seen in this 1946 image, the street car barn still functioned as the turnaround for the baths.

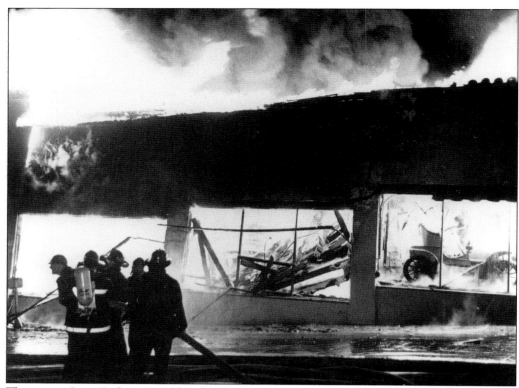

The vacant Sutro Baths were sold to developers in 1966, and they burned down shortly thereafter.

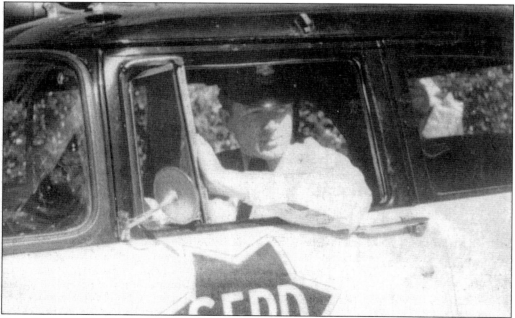

Tom Dickson (the father of co-author Jim Dickson), a retired San Francisco police officer, arrested the boy who later admitted that he had burned Sutro Baths down in June 1966.

Five

GINGERBREAD CLIFF HOUSE

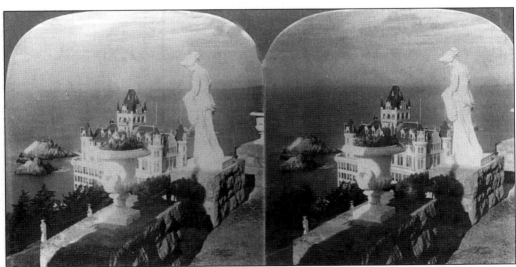

After the loss of the Cliff House in 1894, Adolph Sutro vowed to rebuild, and he did so magnificently. The so-called "Gingerbread Cliff House" was a dramatic building that captured the world's fancy. The French Chateau design cost $50,000, and the resultant grandiose building hosted many of the luminaries of the day, such as Sarah Bernhardt, Adelina Patti, Presidents Hayes, Grant, Roosevelt, and Taft, as well as all types of local celebrities. Sutro, in his quest to attract families, discontinued offering hotel services, leading the Cliff House to become a popular venue for dining, receptions, private lunches, galleries, gift shops, and exhibits.

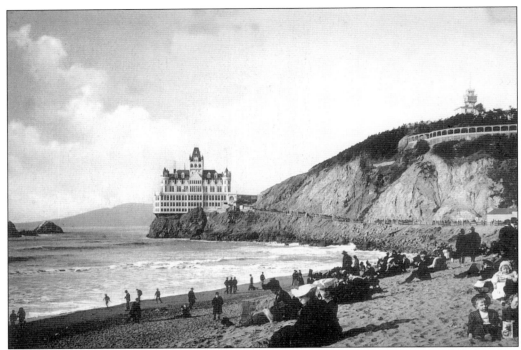

In *Over the Range to the Golden Gate—A Complete Tourist Guide*, Stanley Wood declared in 1904 that "The Cliff House offered all creature comforts obtainable." Indeed, Sutro made all efforts to attract families and provide educational experiences for the public, just as he had done at the baths.

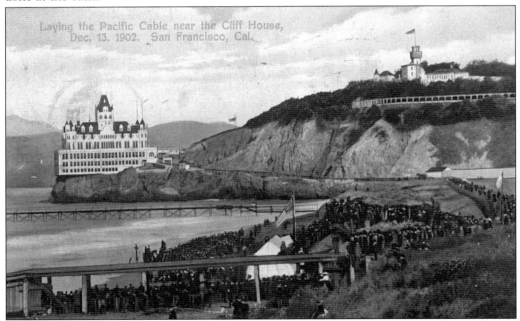

Laying the Pacific Cable near the Cliff House, Dec. 13. 1902. San Francisco, Cal.

About 10,000 people thronged the beach to view the laying of the first trans-Pacific cable to the Orient near the Cliff House.

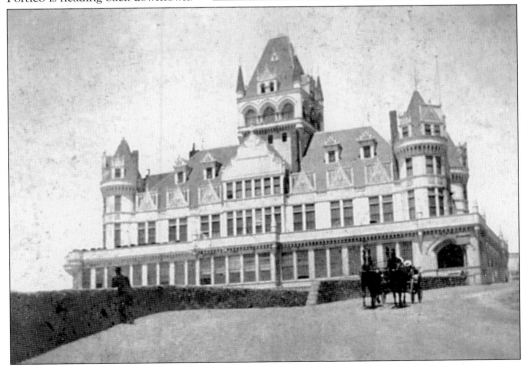

The smart hotels offered daily rides to the Cliff House. A "back east" custom was inaugurated. Daily rides of 12 people atop coaches were driven by "smart" young men of social importance. In the image below, a carriage leaving North Portico is heading back downtown.

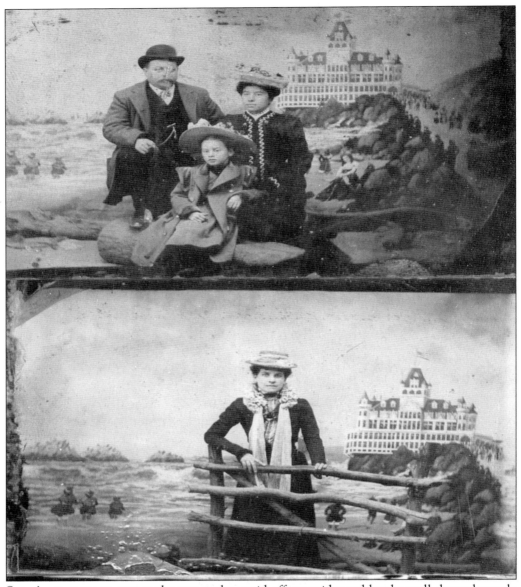

Sutro's attempts to attract the upper class paid off, as evidenced by the well-dressed people in these two tintype photos.

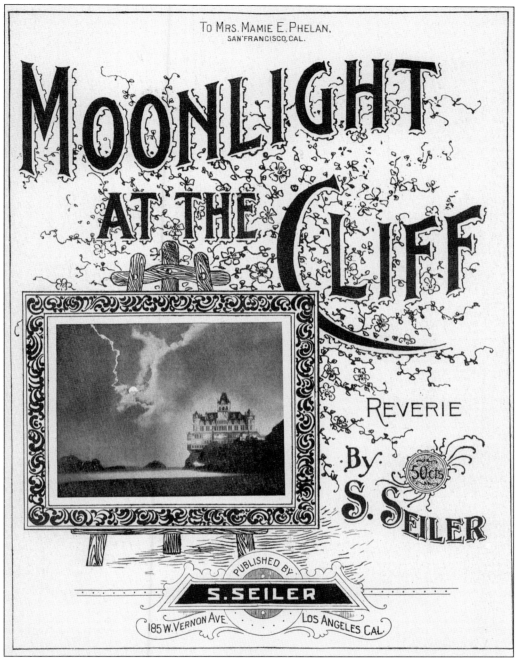

The Cliff House stayed in the national spotlight for many years, thanks to such items as this dramatic piece of 1901 sheet music, dedicated to Mrs. Mamie Phelan of the prominent San Francisco family.

The gift shop sold souvenirs and photos, such as this fine wall plaque and porcelain plate.

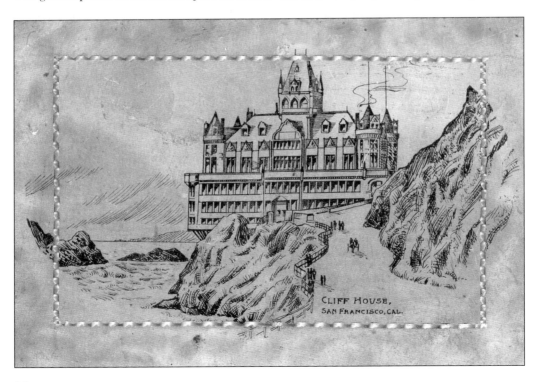

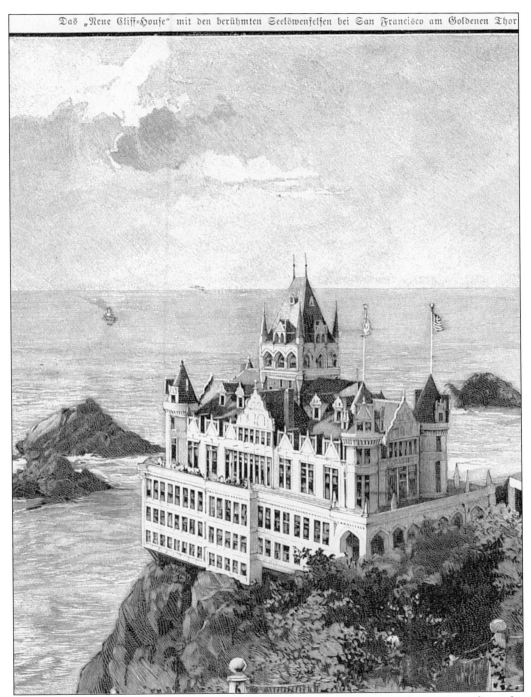

The Cliff House's international fame is evident by this excellent wood engraving from the German publication *Illustrite Welt*.

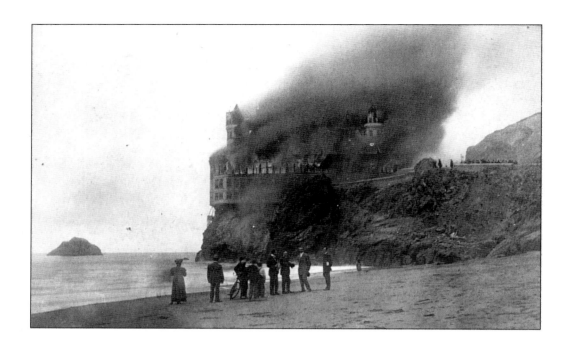

While closed for renovations in 1907, the Cliff House burned to the ground. Here are two postcards that depict some of the hundreds of views of the disaster sent around the world. One wonders about the caption, "Good Luck from San Francisco," as it sounds like San Francisco might not survive the loss.

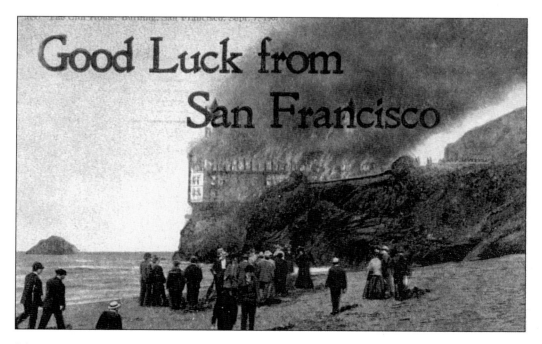

Six

Other Attractions at Ocean Beach

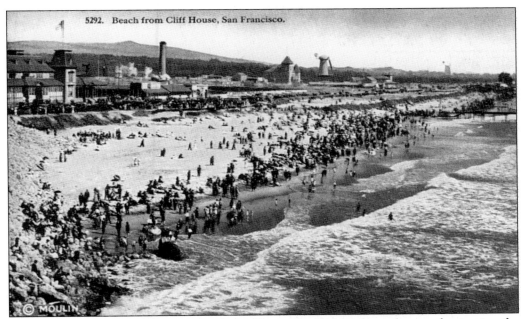

5292. Beach from Cliff House, San Francisco.

The spectacular edge of the city that hosts Ocean Beach has always been a destination for pleasure-loving San Franciscans. This five-mile span of gorgeous open beach has attracted development, amusements, and recreation for better or worse. It is arguably the best big city seaside walk in the world.

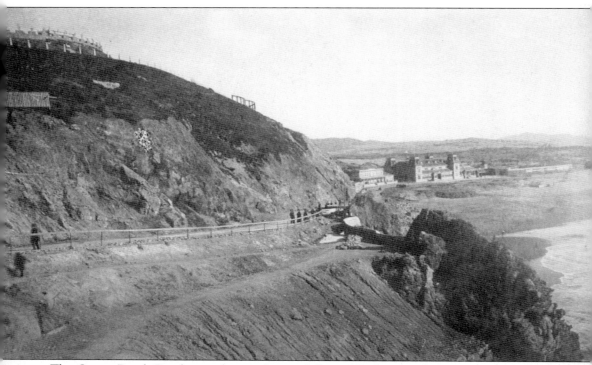

The Ocean Beach Road curved up and around Sutro Heights. At this time (c. 1890) it was a dirt road with a wooden railing. The parapet can be seen at the top of the Heights. It was reminiscent of a castle wall with Greek and Roman statuary at intervals.

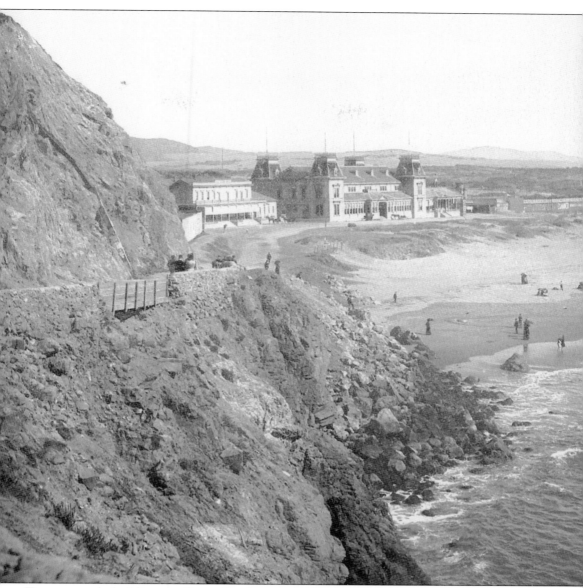

Two very early buildings at Ocean Beach were the Seal Rock Hotel, with its café and grill (opened in 1858), and the Ocean Beach Pavilion (following a few years later 1884). Both were popular early gathering places. The image shown here is from a glass negative.

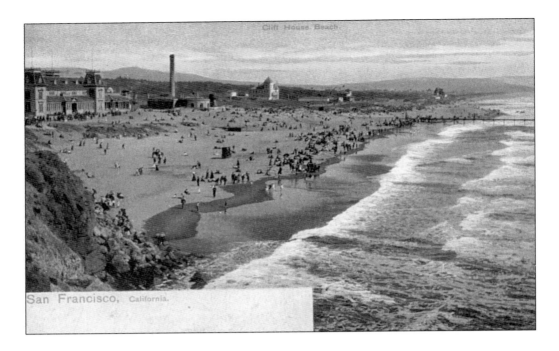

These two early views, c. 1910, are looking southward, showing a large pumping station beyond the Beach Pavilion. There, sugar magnate John Spreckels, who was also president of the Olympic Salt Water Company, built a 600-foot iron pier that was a pipeline for salt water intake. The company supplied ocean water to the Lurlene Baths at Bush and Larkin and other downtown customers.

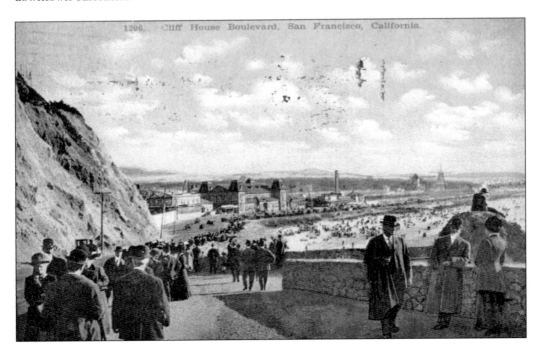

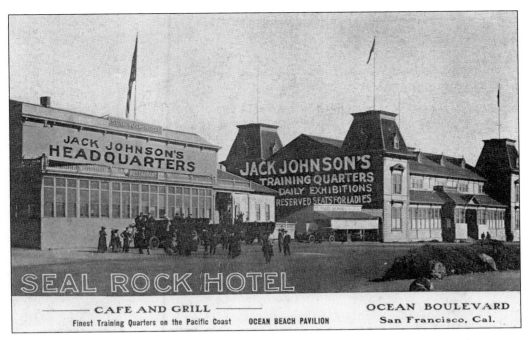

Jack Johnson, the heavyweight boxing champ is at the wheel of his promotional car with manager Tex Rickard at the Seal Rock Hotel in this June 1910 photograph. The Johnson/Jefferies fight held on the 4th of July in Reno, Nevada, was called "The Fight of the Century." Former champ James Jefferies came out of retirement to challenge Johnson, but lost! Riots broke out throughout the country when "The Great White Hope" was knocked down in the 15th round.

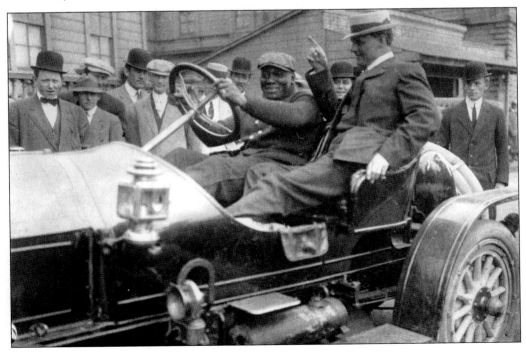

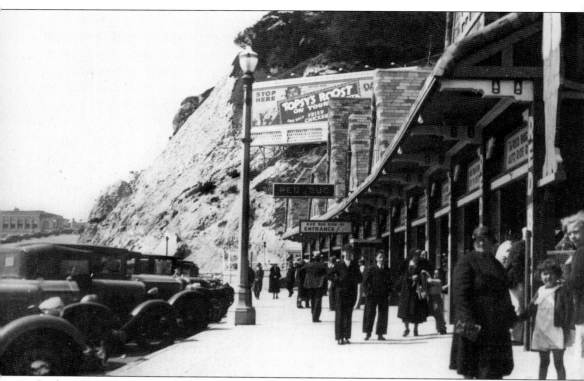

In the 1930s, Ocean Beach featured a dance hall, restaurant, and amusements in part of the old Ocean Beach Pavilion. People liked to wander out of Golden Gate Park and from the Beach to get a bite to eat and to enjoy a game of skill and to promenade. The billboard for Topsy's Roost restaurant sits halfway up Sutro Heights. The Cliff House can be seen at left.

This menu for the Famous Topsy's Roost described its fare as "food you could eat with your fingers."

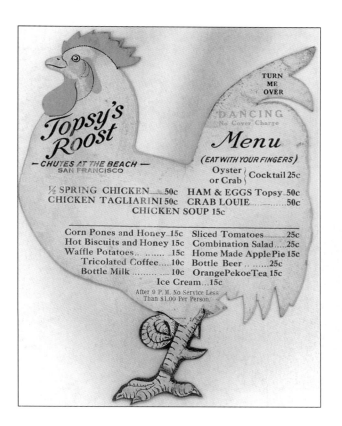

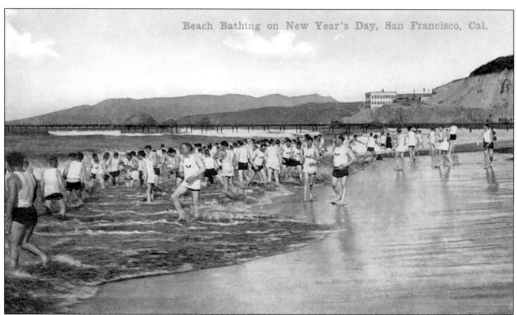

New Year's and Christmas dips in the frigid Pacific Ocean were, and remain, a popular phenomenon.

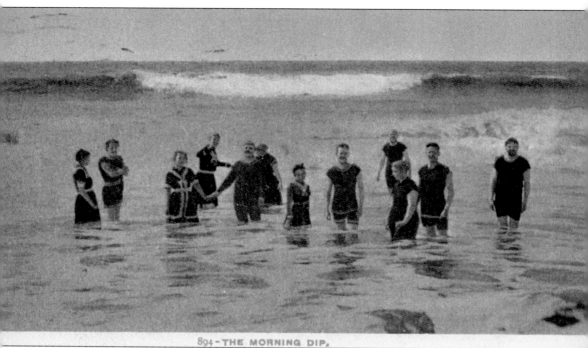

894 - THE MORNING DIP.

On December 24, 1911, an annual event by the Dolphin Club went from the foot of Van Ness Avenue to Ocean Beach—a six-mile run. Afterwards, participants enjoyed a 15 minute dip, and then dinner and entertainment at the Seal Rock House. The man second from left looks as if he is feeling the effects of the almost frigid water.

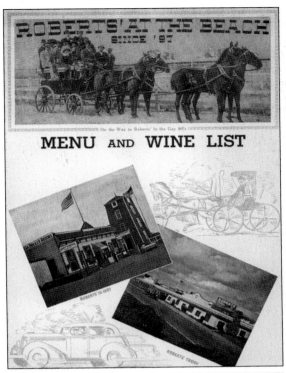

This is the front and back cover of a "Roberts' at the Beach" restaurant menu. The caption reads, "Founded in 1897 by 'Shorty' Roberts and known as the 'Sea Breeze Resort,' this rendezvous has grown and progressed with San Francisco and now stands today a landmark for the connoisseur, fastidious imbiber and gourmet who like to dine royally. Although strictly up to date in every way 'Roberts' at the Beach' endeavors to retain that atmosphere reminiscent of the 'Gay 90s' that made San Francisco famous throughout the world. The only rendezvous with a tradition dating back to 1897. Family owned—family operated."

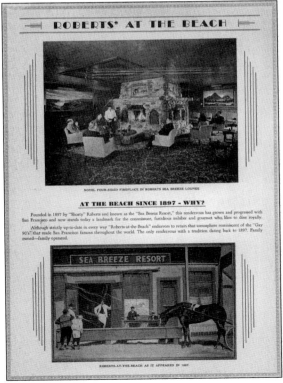

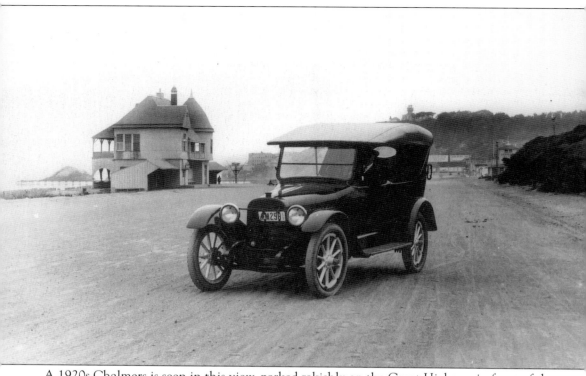

A 1920s Chalmers is seen in this view, parked rakishly on the Great Highway in front of the Ocean House. At one time this was the widest highway in America. What is unusual in this car ad photo, is the empty street which was normally clogged with many vehicles.

The original Beach Chalet was on the Ocean Side of the Great Highway, and later rebuilt on the east side. The new Beach Chalet was designed by Willis Polk. It opened to the public in 1925, with a first floor lounge, and the second story holding changing rooms and a dining area. During the Depression the Works Progress Administration was responsible for creating huge murals (designed by Lucien Labaudt), wood carvings, and mosaics. The Beach Chalet was occupied by the Army during World War II, and today this architectural jewel has a restaurant upstairs with a large gift shop on the main floor, still surrounded by the colorful murals.

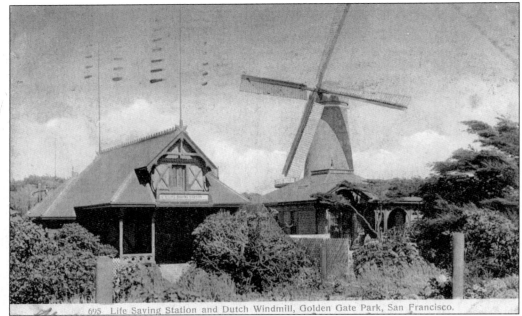

695 Life Saving Station and Dutch Windmill, Golden Gate Park, San Francisco.

In 1902 a Dutch windmill was built at the western entrance to Golden Gate Park. It was a big success and the power furnished by the wind pumped water to irrigate 70 acres of park. Eventually it was equipped with an electric pump. The windmill went into a state of decline but was restored in the 1990s. A second one called "The Murphy Windmill" was built in 1907, and will be restored soon.

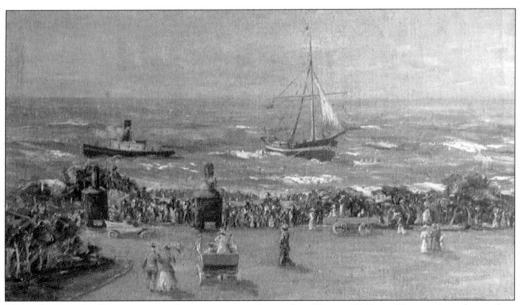

Near the windmill was an outdoor museum piece, the 47-ton *Goja*, a Norwegian sloop that visited the Arctic under the command of Roald Amundsen. The ship remained at Ocean Beach until it was returned to Norway in 1972. This oil painting from 1904 is by Carl August Heliodor Hammerstrom (1866–1954), who had a studio behind the windmill.

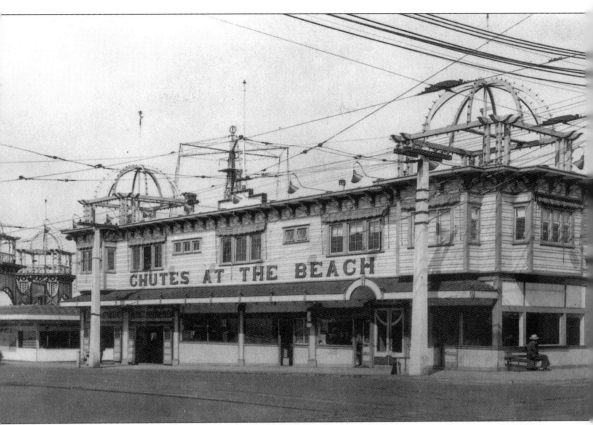

The Chutes at the Beach, seen here in the 1920s, was a popular attraction that preceded the Playland at the Beach amusement park. This area was a continuation of the Ocean Beach Pavilion area.

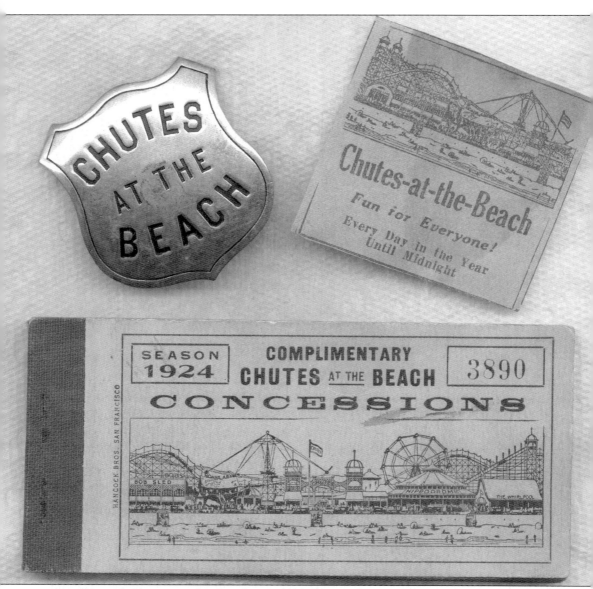

A collage of Chutes at the Beach memorabilia can be seen here—including an official employee's badge. The concession book from 1924 has tickets for rides such as the Bug House, the Sleigh Ride, Noah's Ark, Bob's, The Whirlpool, Ship Ajoy, and the Frolic.

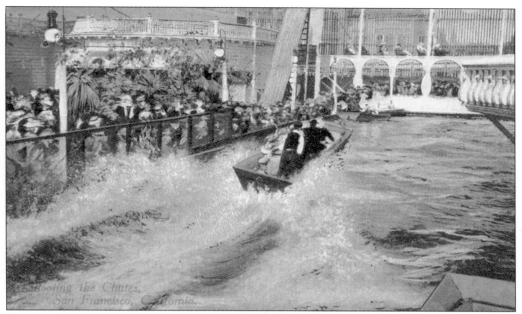

As seen in this 1912 image, the chutes amusement ride consisted of two boats holding several passengers, going down a steep incline, then through a tunnel, and finally down a chute into a pond.

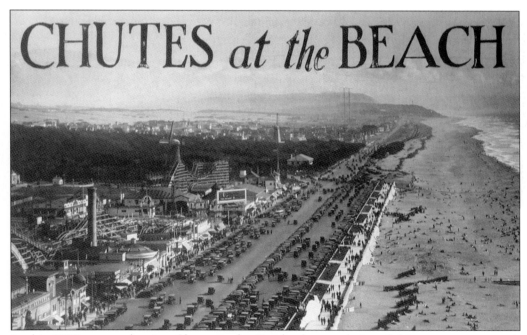

CHUTES *at the* BEACH

In this 1920s poster showing Chutes at the Beach, the popularity of this amusement area is evident. The developing Sunset area is in the background, and the windmills, Beach Chalet, and the wind screens on Ocean Beach can all be seen.

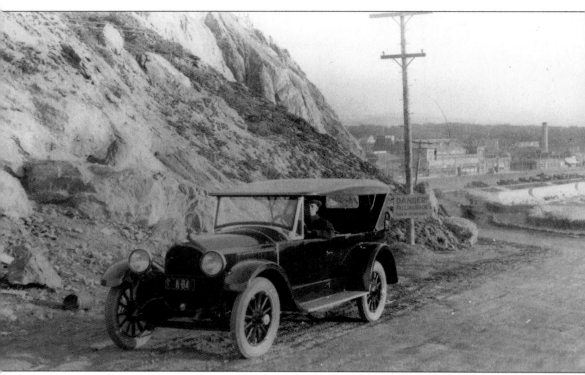

This old photo shows a 1925 Paige auto in front of a sign warning "Danger: Falling Rocks." When the road was widened that year, this problem was solved by securing a metal frame over the cliff and covering it with concrete resembling rocks. These "rocks" created a lot of talk as they resembled a Hollywood set. As they wore away they provided sanctuary for individuals and their fires sometimes created smoking rocks! Finally the whole apparatus was removed in the 1970s despite protests to "Save Our Rocks."

MODERN CLIFF HOUSES

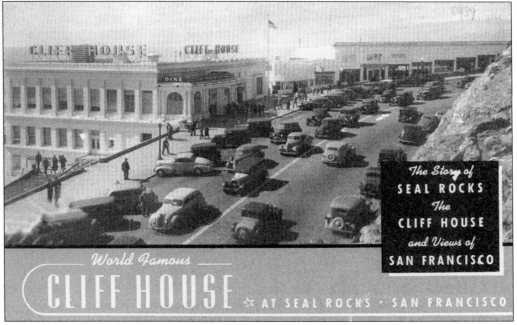

After the demise of the Gingerbread Cliff House, Sutro's daughter Emma rebuilt the resort in 1909 with concrete and steel. In 1937 the Whitney Brothers added this building to their beach area holdings, and the Cliff House became a modern tourist destination. Today tour buses and locals flock to the Cliff House just like the old days for viewing, dining, and beverages. And just like in the old days, it sometimes becomes impossible to park.

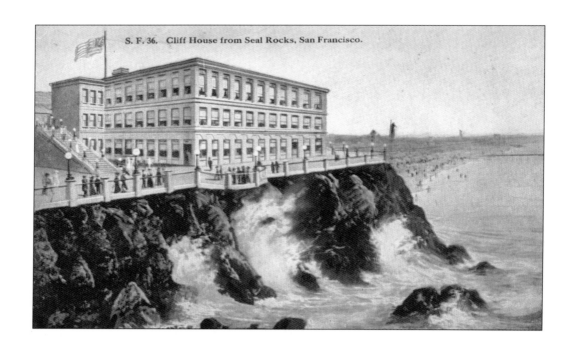

S. F. 36. Cliff House from Seal Rocks, San Francisco.

Sinclair Lewis described a day at Ocean Beach as "A San Francisco Pleasure Cure" for *Sunset Magazine* in 1910. He wrote, "When they went autoing to the beach, from the terrace of the new Cliff House, they watched the absurdly grave and bearded sea-lions waltz through the ethereally blue waves. They looked up the training quarters of the world-famed pugilist, and dropped in at the mild little road houses along the perfect boulevard . . . the enormous yellow crescent of hard beaches, edged with sunny foam and scattered with colorful picnicking parties—overlooked the vast sweep of sea—from Golden Gate to Far Cathay!"

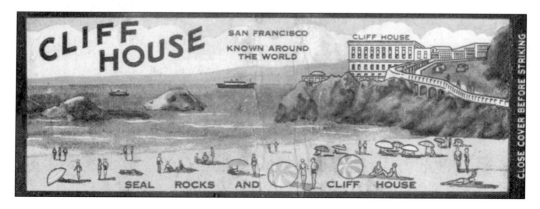

Girl Swims Around Seal Rocks

Ella Crist Accomplishes Feat

Novice With Ten Months' Experience Shows Good Nerve

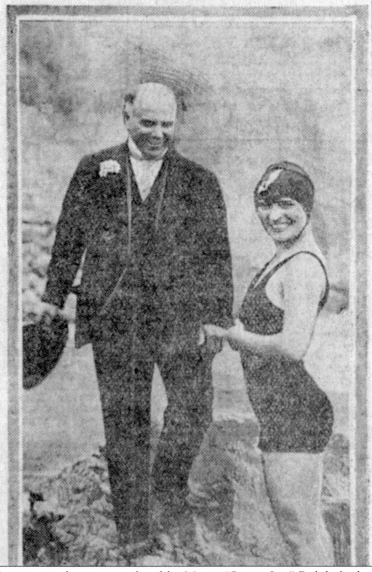

ELLA CRIST swam around the four Seal rocks from the base of the Cliff House in 56 minutes 47 1-5 seconds yesterday forenoon. This doesn't approach Nell Schmidt's record of 34 minutes 50 seconds, but is considered remarkable because Miss Crist learned to swim only ten months ago and has never tried a long swim before.

She made the last quarter-mile of the mile and a quarter on her nerve, and collapsed when she got to shore.

"She was all in, but she wouldn't give up," said Captain Norman Nelson, who, with a crew of life-savers, accompanied her in a boat. "It was her birthday."

More than 200 had gathered to watch Miss Crist

Ella Crist, a local San Francisco girl is congratulated by Mayor "Sunny Jim" Rolph for her Seal Rocks swim.

110 Years of San Francisco
MY MEMORIES
by VICTOR F. POLLAK

Victor Pollack recalled in his memoirs at the Cliff House, "The bird man had trained canaries and parrots. He put on a show with one canary standing in front of a small cannon with an empty coffin, another canary would pull the string and the first canary would fall into the coffin, the parrot would pass the hat."

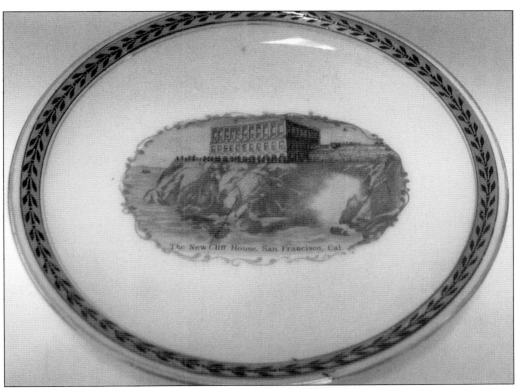

Souvenir plates have remained popular items to tourists for many years. The plates showing the "new" Cliff House as it appeared in 1909, and the remodeled Cliff House from the 1950s with two new dining rooms are prime examples.

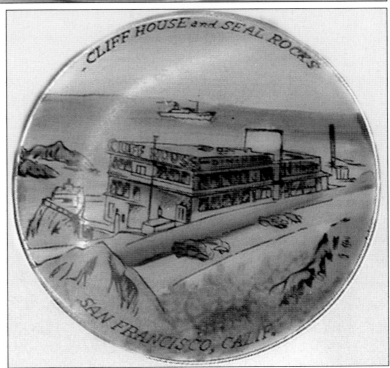

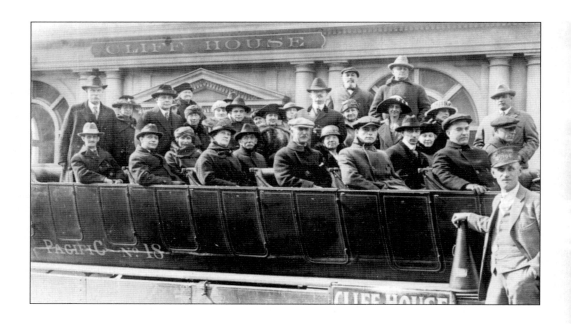

Tourists continued to enjoy the Cliff House in the 1920s and 1930s.

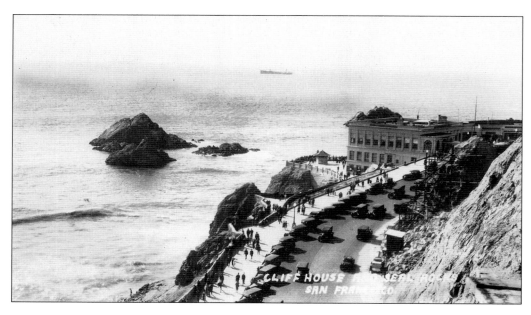

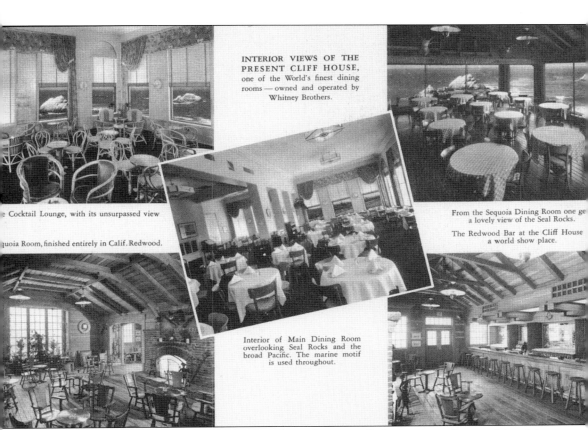

INTERIOR VIEWS OF THE PRESENT CLIFF HOUSE, one of the World's finest dining rooms — owned and operated by Whitney Brothers.

e Cocktail Lounge, with its unsurpassed view

quoia Room, finished entirely in Calif. Redwood.

From the Sequoia Dining Room one ge a lovely view of the Seal Rocks.

The Redwood Bar at the Cliff House a world show place.

Interior of Main Dining Room overlooking Seal Rocks and the broad Pacific. The marine motif is used throughout.

This popular gathering spot continued to be a "must see" destination. Pictured in this interior view of the Cliff House are the Sequoia Room, the main dining room, the cocktail lounge, and the Redwood Bar. The bar and the Sequoia Room were lined in redwood with beamed ceilings which resembled a ship's interior. Naturally there were many windows throughout to encourage viewing of Seal Rocks and the Pacific ocean.

A late 1970s menu pictured Charles Dana Gibson's Bathing Beauties. America's turn-of-the-century women all wanted to be as beautiful as the "Gibson Girls." In keeping with the glamorous theme, the Cliff House promised, "You're in great company at the Cliff House where we've been welcoming friends since 1854. First came gold rush miners of '49. Bawdy with Bullion. They invented the word 'revel' we're sure. Then the gay '90s and we were very social with lots of chandeliers and Nob Hill tycoons alighting full-dress from sleek Victorian carriages. Mark Twain would Sunday Brunch here. Sarah Bernhardt dined after the show. President Hayes, Grant, McKinley, Roosevelt and Taft all guested. Following World War I we became the Charleston 'discotheque' of the day. Babe Ruth loved it as we flappered through the roaring twenties. Our 100th birthday was celebrated in the 1950s and today we're looking forward to our SECOND lap around the century."

This exceptional menu cover was especially painted in the mid-1950s for Whitney's World Famous Cliff House.

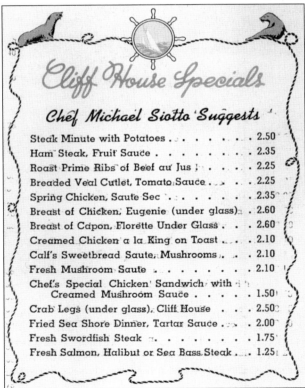

Cliff House Specials

Chef Michael Siotto Suggests

Steak Minute with Potatoes	2.50
Ham Steak, Fruit Sauce	2.35
Roast Prime Ribs of Beef au Jus	2.25
Breaded Veal Cutlet, Tomato Sauce	2.25
Spring Chicken, Saute Sec	2.35
Breast of Chicken, Eugenie (under glass) .	2.60
Breast of Capon, Florette Under Glass . . .	2.60
Creamed Chicken a la King on Toast . . .	2.10
Calf's Sweetbread Saute, Mushrooms . .	2.10
Fresh Mushroom Saute	2.10
Chef's Special Chicken Sandwich with Creamed Mushroom Sauce	1.50
Crab Legs (under glass), Cliff House . . .	2.50
Fried Sea Shore Dinner, Tartar Sauce . . .	2.00
Fresh Swordfish Steak	1.75
Fresh Salmon, Halibut or Sea Bass Steak . .	1.25

This menu illustrates how much things change over time; the specials of the day include salmon at $1.25.

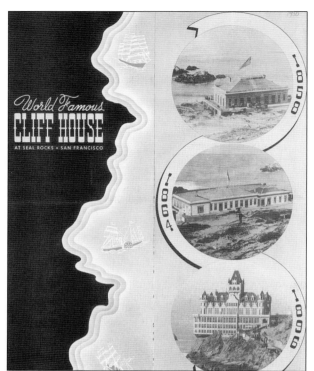

Shown here is one of the now-collectible menus that was indeed a barometer of social history. In the 1940s, a crab dish was 50¢, and by 1950 it sold for $1.10, and $3 by 1960. This attractive menu of 1950 showed the three stages of the Cliff House.

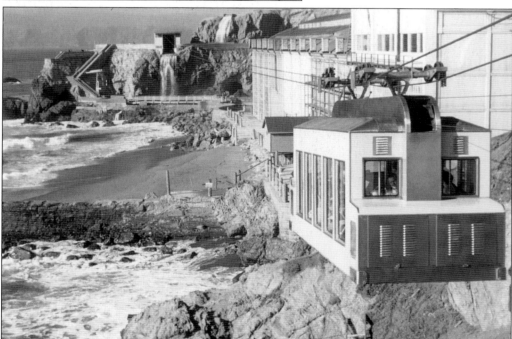

A "Sky Tram," similar to a ski lift, gave a great view above the ocean edge and ran from the Cliff House to Point Lobos. The tram station displayed huge photos of ship wrecks at Land's End, a rocky point not far from the Cliff House.

Eight

PLAYLAND AT THE BEACH

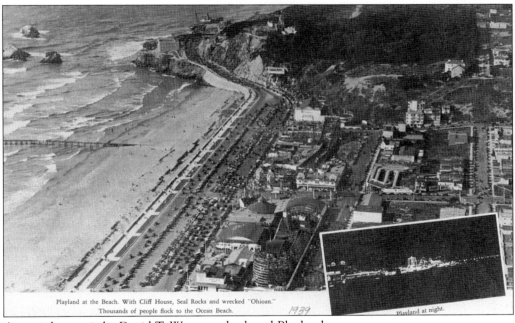

Playland at the Beach. With Cliff House, Seal Rocks and wrecked "Ohioan."
Thousands of people flock to the Ocean Beach. *1939*

Playland at night.

A special memoir by David T. Warren, who loved Playland:

--"Playland at the Beach" was a special place, its purpose was clear, and it was a fun place. People went there to relax and get away from the work-a-day world. "Escape" might also define its purpose, but it was more than that. For the young it was a fantasy land of their first kiss, a place to test their strength, and learn who they really were. It was a place where an apparently crooked world might straighten out before their eyes (maybe), and where the individual might learn to separate the strange forces of equilibrium and illusion from the real and not so real. Where kids could stay as long as they liked, perhaps slay the dragons of their fears (and live to dream about it), and in the mean time discover who they really were. All this and more was the prize waiting at the end of the line, at that special place we came to call "Playland."

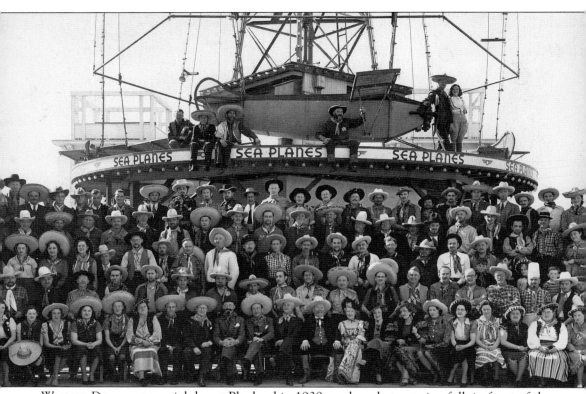

Western Day was a special day at Playland in 1939, as these hat-wearing folk in front of the Sea Plane ride illustrate. Other popular days highlighted fraternal groups.

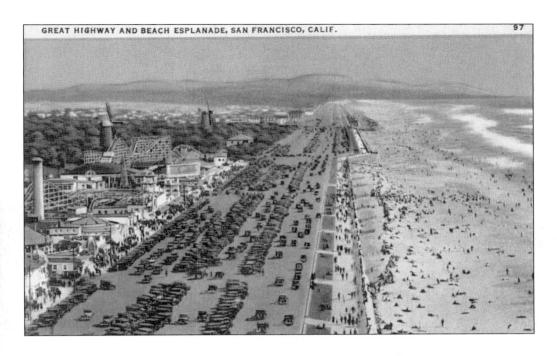

In 1929, the Whitney brothers (George and Leo) were successful in taking over this Playland area of rides, games of chance and skill, fun house, and eating establishments.

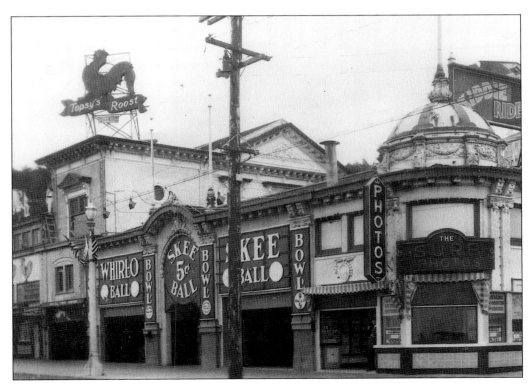

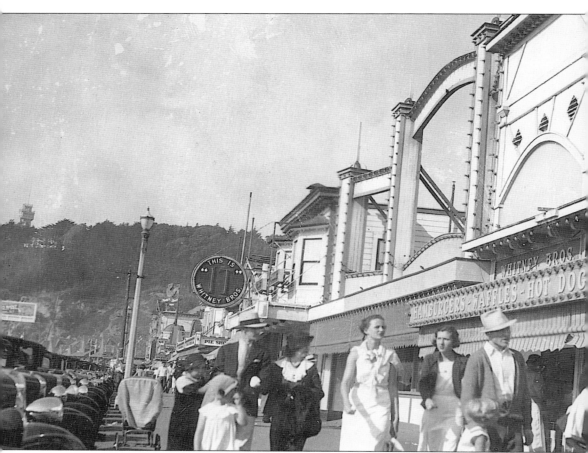

This sign on Playland's promenade read "This is 'IT' Whitney Brothers," meaning this is where it all is. Throughout the 1930s, 1940s, and 1950s, flocking San Franciscoans seemed to agree.

"Laughing Sal" presided over the Fun House and greeted all with her eerie cackle. Many a child of San Francisco had horrifying nightmares about this figure. She can still be seen at the Museé Mechaníque.

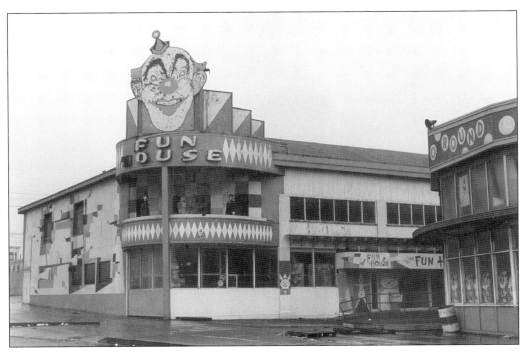

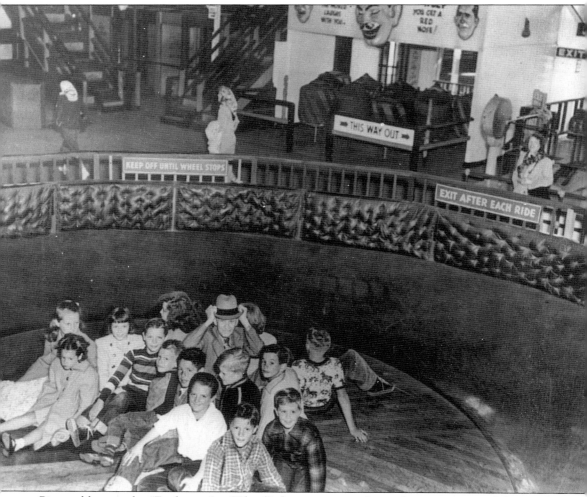

Pictured here is the "Funhouse Joy Wheel" that spun around very fast as everyone slid toward the sides. The object was to get to the center of the wheel and not be thrown off. This created great mayhem. Hilarity ensued.

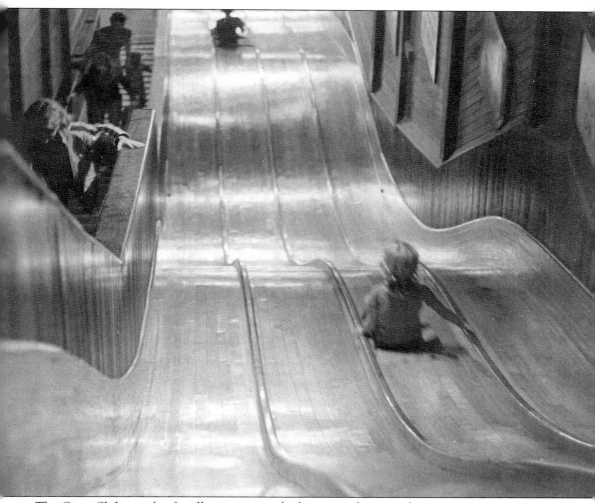

The Giant Slide was fun for all ages, testing the kinetic endurance of participants.

"The Limbo" at Playland was a scary ride in the dark. Riders in a self-propelled car looped past terrifying creatures and noises.

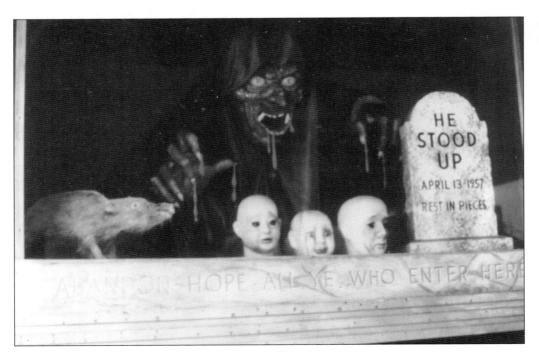

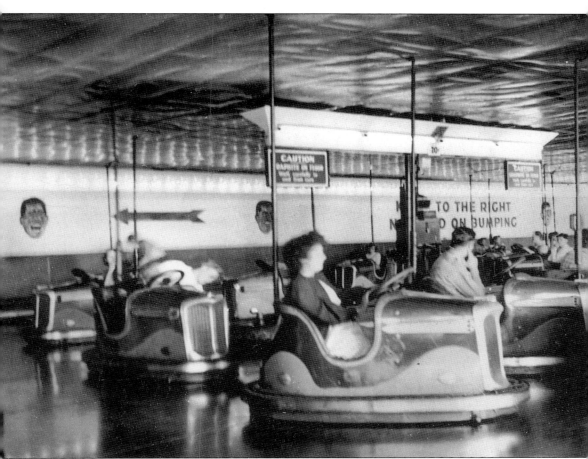

The Bumper Cars were called "Dodgers."

"The Diving Bell" was famous for shooting out of the water, then splashing up and down. When under the water, occupants looked through a tiny porthole at fish and other types of small sea life.

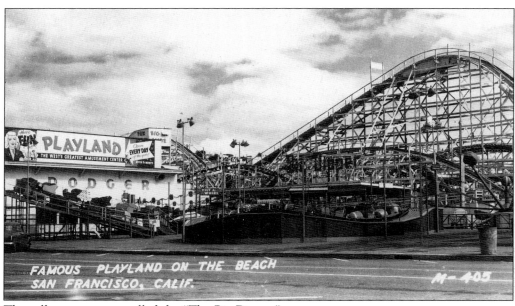

The roller coaster was called the "The Big Dipper."

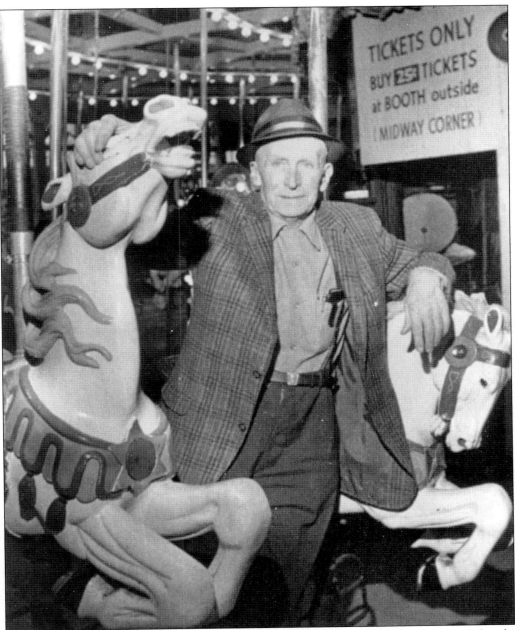

Wilhelm Smit ran the "Big Dipper" and the merry-go-round from 1923 until Playland closed.

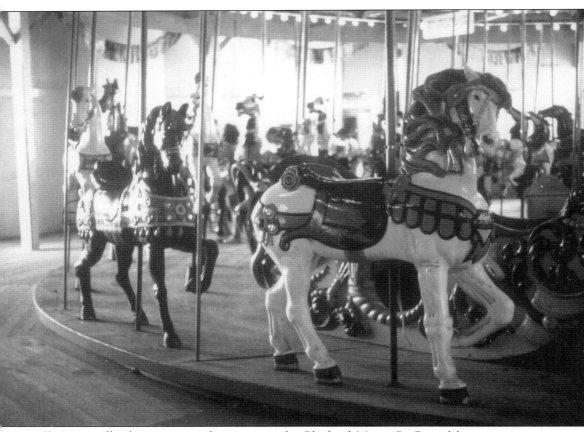

You can still take a spin on this ever popular Playland Merry-Go-Round because it is now located in San Francisco's Yerba Buena Center.

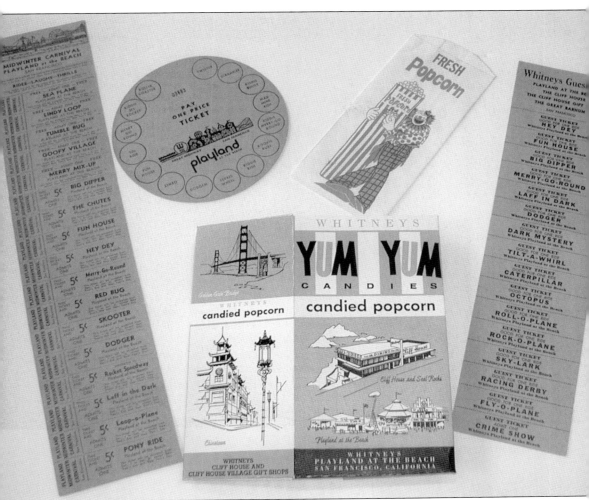

Here is an assortment of Playland ride tickets ranging from around 1935 to the mid-1960s. Some of the rides listed are "Kiddie Jet Rocket," "Merry Go Round," "Fun House," "Limbo," "Dodgem," "Twister," "Mad Mine Ride," and "Laugh in the Dark," along with many others. As for sugary treats, candied popcorn and cotton candy were some of the choices available.

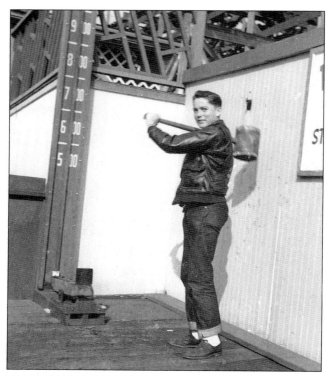

In this 1940s-era photograph, Bill Smit, Wilhelm's grandson, is pictured with the game of skill "Ring the Bell" (also known as "High Striker").

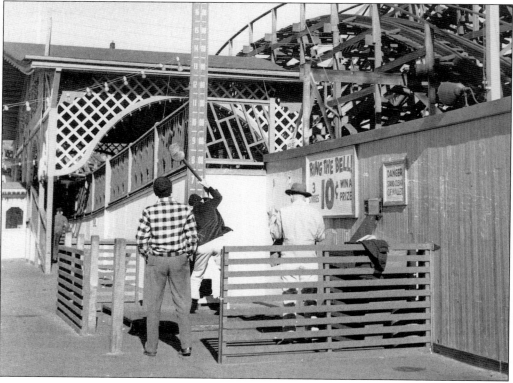

WHITNEY BROS' FAMOUS
PLACES TO DINE
AT THE BEACH

The HOT HOUSE

SPECIALIZING IN ENCHILADAS · TAMALES · TOSTADAS · CHILE RELLENOS AND OTHER DELICIOUS MEXICAN AND SPANISH DISHES · PREPARED BY EXPERTS AND SERVED IN THE DELIGHTFUL ATMOSPHERE OF SUNNY MEXICO

The "IT" STAND

FAMOUS FOR PLATE BROILED STEER MEAT HAMBURGERS COOKED WITHOUT GREASE · AND ELECTRIC GRILLED HOT DOGS CONTAINING VITAMIN "D" · MADE ESPECIALLY FOR OUR USE · GOOD COFFEE ALWAYS

The PIE SHOP

HOMEMADE PIES & CAKES TURNOVERS · SANDWICHES · FRESH FROZEN ICE CREAM AND FOUNTAIN SPECIALS · ALL ICE CREAM, PIES & CAKES SERVED IN WHITNEY BROS. RESTAURANTS AND STANDS ARE MADE HERE

The SEA LION Café

BREAKFASTS · LUNCHES · DINNERS · STEAKS · CHOPS · HAM AND EGGS · WAFFLES · HOT OR COLD SANDWICHES · HOME MADE PIES · SPECIAL SUNDAY DINNERS · THE SEA LION IS A POPULAR PLACE FOR SUNDAY BREAKFASTS

The WAFFLE SHOP

SPECIALIZING IN CREAM WAFFLES · STRAWBERRY AND PECAN WAFFLES HOT CAKES WITH LITTLE PIG SAUSAGES, BACON OR HAM · STEER BEEF HAMBURGERS · ELECTRIC GRILLED HOT DOGS · CHOW MEIN · PIES & CAKES

TOPSY'S ROOST

FEATURING THE WORLD'S MOST DELICIOUS FRIED CHICKEN · BAKED HAM · CHICKEN PIE · CORN PONES · HOT BISCUITS · WAFFLE FRIED POTATOES · AND OTHER DELICIOUS SOUTHERN DISHES · DANCING · PARTIES & BANQUETS

The CLIFF HOUSE

SAN FRANCISCO'S FINEST AND MOST HISTORIC DINING PLACE · SPECIAL SUNDAY MORNING BREAKFASTS · LUNCHEONS · DINNERS · CUISINE UNEXCELLED · BEAUTIFUL MARINE DINING ROOM · NATIVE REDWOOD BAR AND COCKTAIL LOUNGE

The Whitney brothers owned some of the most popular restaurants at the beach including "The Hot House," "The 'It' Stand," "The Pie Shop," "The Sea Lion," "The Waffle Shop," "Topsy's Roost," and of course, "The Cliff House."

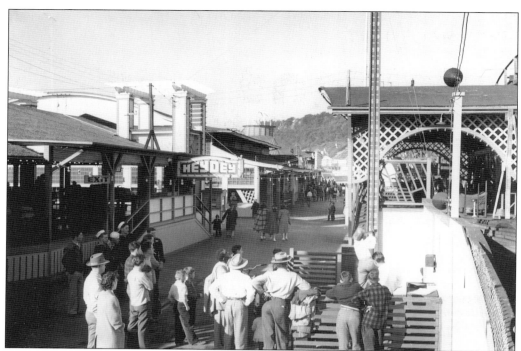

In this early 1940s view, people involved in the quaint practice of "promenading" can be seen in Playland's amusement area.

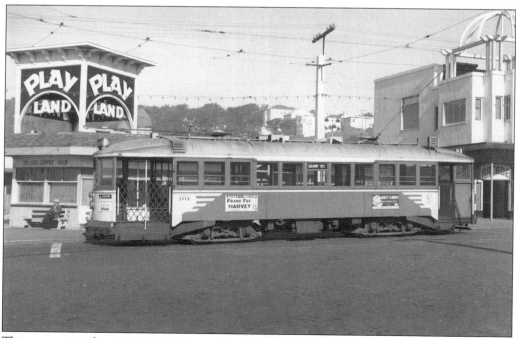

This streetcar to downtown San Francisco is preparing for an "about face" in the B car turnaround.

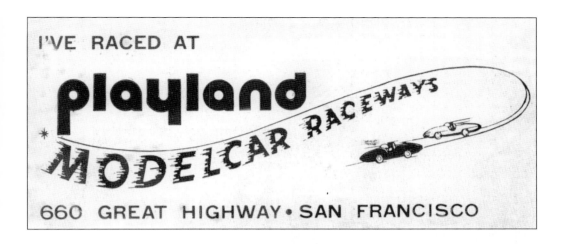

The Ocean Beach Pavilion has been reincarnated in many forms, having been a skating arena, a rock and roll venue (as Family Dog at the Beach), and in one of its most popular lives, as Playland Model Car Raceways.

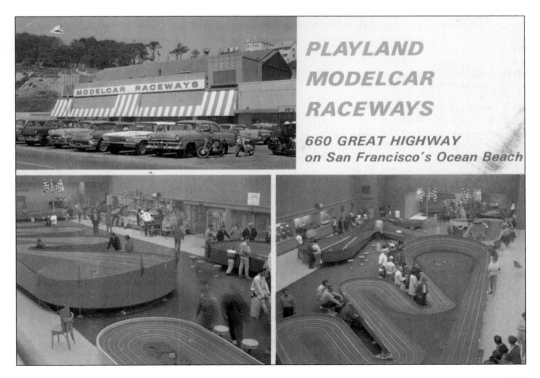

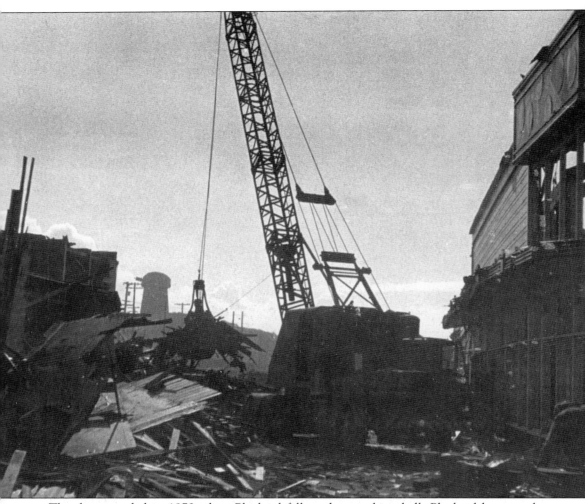

The dream ended in 1972 when Playland fell to the wrecking ball. Playland has now been replaced by oceanfront condominiums.

Nine

FLEISHHACKER POOL, PLAYFIELD, AND ZOO

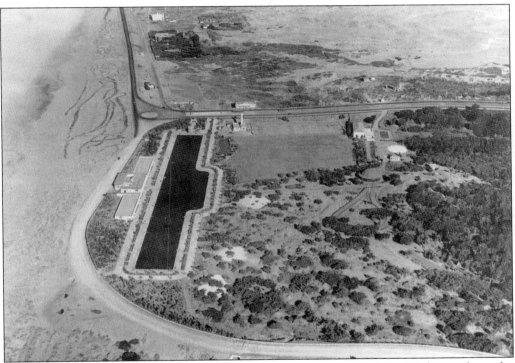

At the end of Sloat Boulevard, at the intersection south of the Great Highway along the coast, the San Francisco Parks and Recreation established another vast recreation complex. In 1922 the city acquired 60 acres from the Spring Valley Water Company for development. Herbert Fleishhacker, a San Francisco banker and head of the City Parks and Recreation Commission, donated (along with his brother Mortimer) a gigantic open-air pool. Also donated was a large "Mother House" where mothers and children could relax and rest between activities. The house, which became the Beach Chalet, was later decorated with impressive large murals by WPA-commissioned artists. For a while it served as the zoo gift shop. Pictured above is an overview of the pool shortly after it was built. The Sunset residential area nearby is still mainly sand dunes and shrub. Sloat Boulevard can be seen along the north. (Courtesy of San Francisco History Center.)

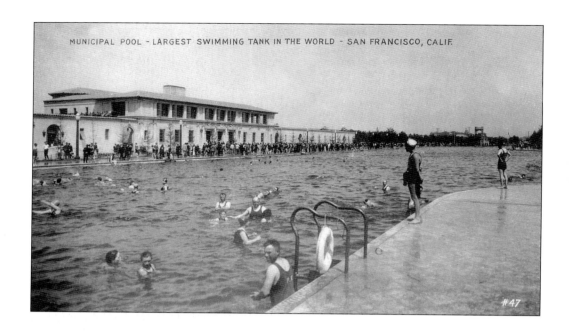

MUNICIPAL POOL - LARGEST SWIMMING TANK IN THE WORLD - SAN FRANCISCO, CALIF.

#47

Fleishhacker Pool was the largest outdoor swimming pool in the world. Measuring 1,000 feet long and 150 feet wide, it held 6,500,000 gallons of water. The large concrete building alongside the pool held ticket rooms, showers, life guard offices, and changing rooms. There was a large restaurant occupying the second floor. A basement boiler room heated the gigantic pool, although many patrons said the water was never warm enough.

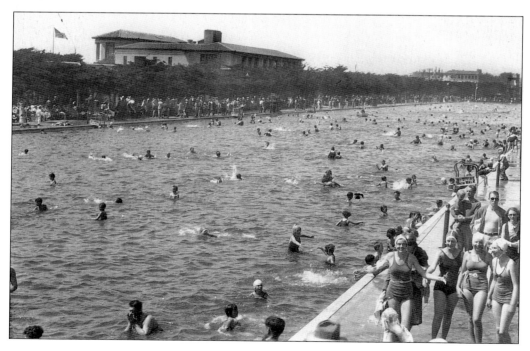

This is an original 1924 wool bathing suit worn by all bathers. The PC on the suit stands for Parks Commission; the pockets in the suit held the locker key. A swimmer would pay 25¢ for adults and 15¢ for children, and was issued a suit and a locker key. Women and men had separate locker rooms and showers. After swimming was over, the suits were washed in huge machines by attendants. In later years, people wore their own suits and brought their own locks for the lockers.

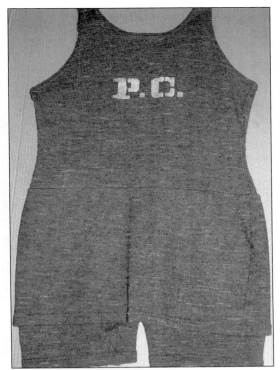

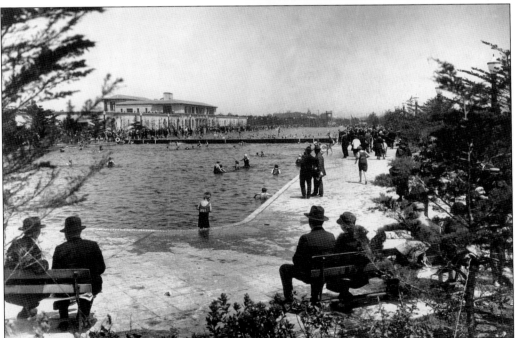

On a Sunday afternoon at Fleishhacker pool, finely dressed spectators watch the swimmers in this photograph. Note the boy with the PC insignia on the back of his suit. (Courtesy of San Francisco History Center.)

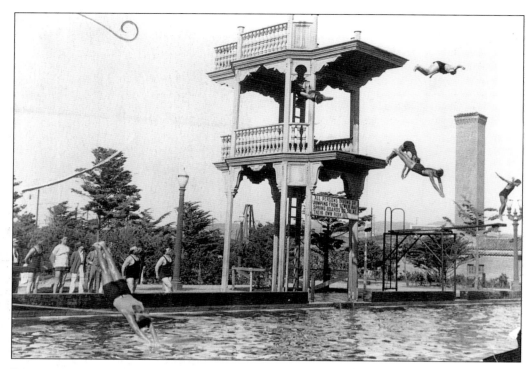

Diving, swimming, and other aquatic events attracted participants from around the world. The depth of the water under the platforms was 14 feet. Diving was carefully regulated, as the huge crowds could number up to 5,000 swimmers. Life guards patrolled in row boats, each assigned to cover a certain part of their colossal pool. The pool was closed in 1971. (Courtesy of San Francisco History Center.)

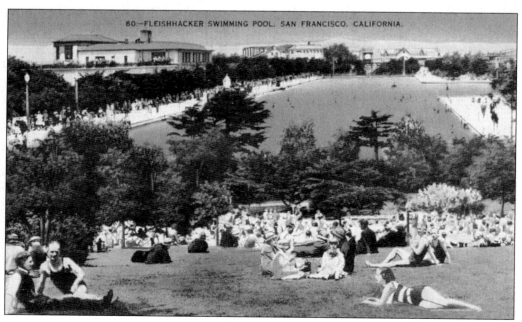

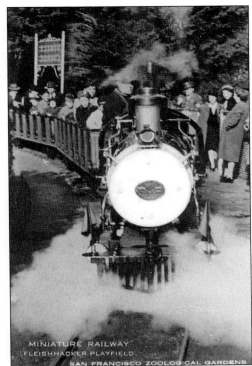

MINIATURE RAILWAY
FLEISHHACKER PLAYFIELD
SAN FRANCISCO ZOOLOGICAL GARDENS

This miniature train circled the playfield by the zoo, bringing delight to children and former children alike. The Fleishhacker family brought the train to San Francisco in 1925, where it remained until 1976. (Courtesy of San Francisco History Center.)

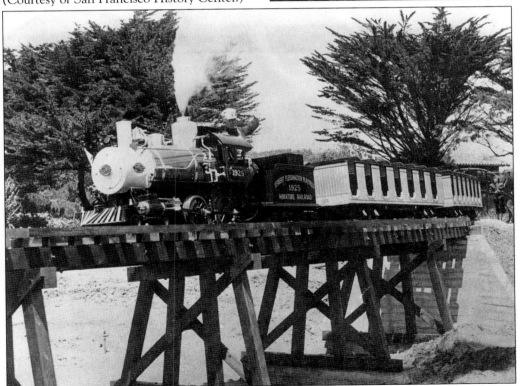

Story Land was populated with Mother Goose and other fairy-tale characters. There were little houses with story characters and a children's petting zoo.

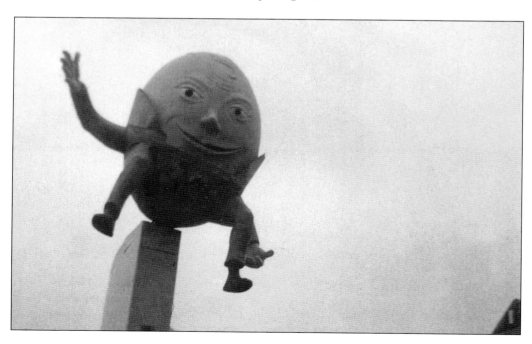

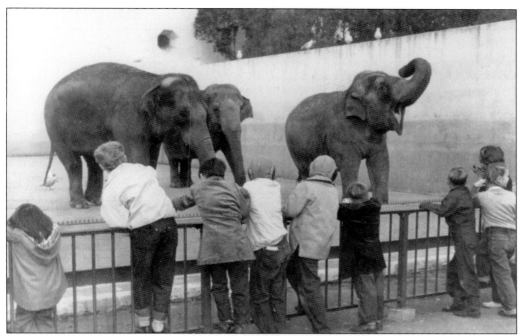

In this 1960s image, children visit the elephants. Then, as now, visitors were normally separated from the animals by a small fence and moat. The zoo featured a natural setting, as much as possible, for each animal. (Courtesy of San Francisco History Center.)

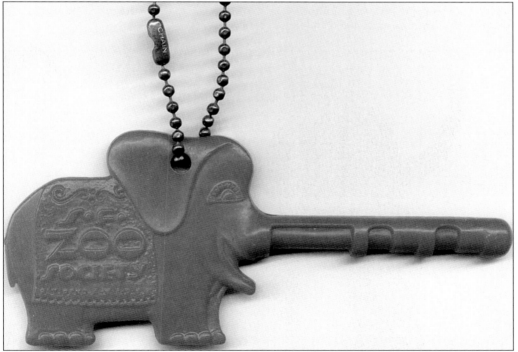

This zoo key was plugged into a box to get audio descriptions of wildlife on display.

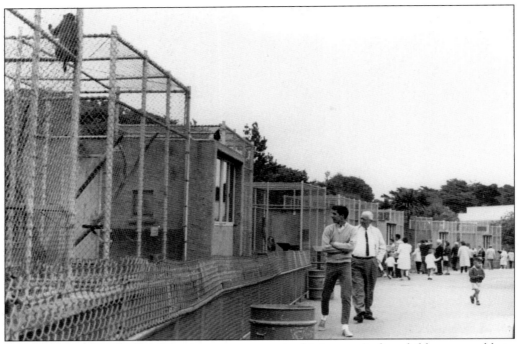

Animals were often displayed in wire cages, as seen in this image. At first children were able to hand-feed the animals, but eventually such practices had to be stopped for safety concerns.

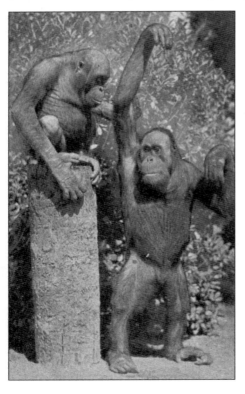

Orang-outangs (*sic*) were popular in the 1930s at the zoo, just as they are today.